POSTCARD HISTORY SERIES

Along New York's Route 20

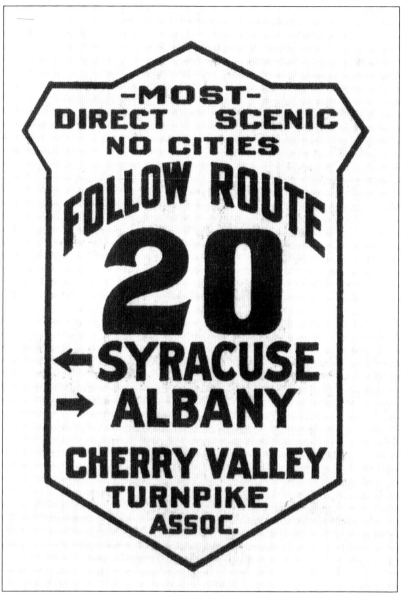

SYMBOL. Pictured above is the 1928 symbol of the Cherry Valley Turnpike United States Transcontinental Route 20.

ON THE FRONT COVER: "For the motorist of 1928, this wonderful highway offers every modern convenience and help to make his journey both interesting and enjoyable—and straight as an arrow over hill and vale. Excellent hotel accommodations, modern garages with competent mechanics dot the course, while its towns not only offer the necessities but the luxuries and attractions that appeal to every taste." (Cherry Valley Turnpike Association, 1928)

ON THE BACK COVER: Roseland Park in Canandaigua, New York, was one of the first amusement parks in the country that was not served by public transportation. Visitors arrived by automobile on Route 20.

POSTCARD HISTORY SERIES

Along New York's Route 20

Michael J. Till

ARCADIA
PUBLISHING

Copyright © 2011 by Michael J. Till
ISBN 978-0-7385-7434-9

Published by Arcadia Publishing
Charleston, South Carolina

Printed in the United States of America

Library of Congress Control Number: 2010935105

For all general information, please contact Arcadia Publishing:
Telephone 843-853-2070
Fax 843-853-0044
E-mail sales@arcadiapublishing.com
For customer service and orders:
Toll-Free 1-888-313-2665

Visit us on the Internet at www.arcadiapublishing.com

To all who remember the crowding and heat in the backseat of the family sedan before the days of air-conditioning, DVDs, and iPods

CONTENTS

ACKNOWLEDGMENTS

Thanks go first to the long-ago civic leaders and business owners who had the foresight to preserve their locations through picture postcards. These visual and historic records provide invaluable insights into the early federal highway era. Thanks also to the vendors of vintage postcards without whose help this book would have been more difficult if not impossible. Many searched for Route 20 cards for me, which was greatly appreciated. The same is true for developers of the Web pages describing towns and historical sites on Route 20. I have borrowed freely from their descriptions and wish to acknowledge their contributions.

To a person, librarians and county historical societies along Route 20 were helpful in finding information, identifying locations, and sharing personal memories of the postcard sites. If someone did not know the answer to a question, a telephone call to a longtime resident of the community usually produced the information. Thus many grandparents, uncles, aunts, and community elders contributed indirectly to this book.

Special thanks go to the Route 20 Association of New York State and John Sagendorf, the administrator, for valuable assistance and encouragement throughout this project. I hope this book will enhance the excellent work that organization is doing to preserve the beauty and history of Route 20.

Last but certainly not least, I wish to thank my wife, Christine, for her help. A librarian herself, she knew sources of information and how to access them. She also was an excellent collaborator as we drove along Route 20 researching specific sites. Many of her observations have been incorporated into the captions in the book.

All images in this book come from the author's personal collection.

INTRODUCTION

The Federal-Aid Highway Act of 1921 was landmark legislation in the evolution of the highway system in the United States. This act provided funding for development and maintenance of seven percent of each state's road system, provided that the roads were "interstate in character." State and federal highway officials, charged with the responsibility of determining which roads should be included, completed their task in 1923. In 1926, these roads were designated "Federal" and a numbering system was adopted, which is still in use today. Major east-west routes were assigned a number ending in 0, and the numbering sequence was from north to south. To avoid the unique number 0, the northernmost road was given the designation 2 and the remaining roads were designated 10, 20, 30, and so forth, to 90. Highways 2 and 10 extended only from the Midwest to the West Coast. From 1926 to 1940, U.S. Route 20 extended from Boston to the east entrance of Yellowstone National Park. In 1940, the western section was completed to Newport, Oregon, making U.S. Route 20 the northernmost of the true cross-country highways, and at more than 3,365 miles, the longest. Although not as famous as its cousins Route 30 (much of which coincided with the original Lincoln Highway) or Route 66 (which is not cross-country), Route 20 nonetheless served with equal importance in introducing automobile and truck traffic to America.

The highway officials in New York who selected the roads to be incorporated into Route 20 got it right. Whether by careful thought or happenstance, their choices were superb. From the Taconic and Catskill ranges in the east to the Finger Lakes in the center and the Lake Erie shore in the west, the new federal highway crossed New York through some of the most beautiful locations in the eastern United States. And by incorporating the Great Western and the Cherry Valley Turnpikes, two of the state's most historic roadways became part of Route 20.

From the very beginning, Route 20 was unique. It was New York's main east-west highway during the first half of the 20th century, but in contrast to most major thoroughfares which connect the larger cities along its course, Route 20 did not. The state capital, Albany, is the only major city through which Route 20 passed. Throughout the remainder of the state, it was routed within a few miles of several large cities—including Schenectady, Utica, Syracuse, Rochester and Buffalo—but did not enter them. Instead it went from village to village on a course leading directly down their main streets. The charm and beauty of rural New York was epitomized along the road.

This rural character has contributed greatly to the longevity of Route 20. The advent of the Interstate Highway System in the 1950s was a boon for motorized travel, but it had a downside. In many locations, the logical course for the new superhighway was directly over a former local highway. The latter was simply bulldozed away, thus completely obliterating its existence and the memories it evoked. Fortunately, Route 20 in New York is an exception. It has survived almost entirely in its original configuration. Since Route 20 missed most of the major cities, it was left essentially untouched and to this day remains a pristine "country highway." The later

interstate highways parallel Route 20 rather than being superimposed directly on top. While it is true that certain sections of the original highway have been realigned and widened to four lanes, and some towns now have bypass options, in most places where this has occurred the roads that carried "original" Route 20 still exist. Local numerical or street name designations may have been assigned, but with a bit of effort one can still follow historic Route 20 across the state much as our ancestors did in decades gone by.

Early motorists got a close-up view of the towns and cities along the path of their journey, and they took advantage of the stores, restaurants, service stations, and tourist accommodations in these communities. City officials and individual merchants soon recognized the value of advertising their wares to the traveling public as a means of attracting more visitors. Inexpensive or even free picture postcards were a popular vehicle for showing off their cities. Professionally produced picture postcards provided a convenient record of the trip, and typically they were less expensive and of higher quality than travelers could produce with their own cameras. Thus many postcards found their way into personal scrapbooks, and others sent to friends and relatives back home have been preserved. These postcards provide the basis for this book.

This is not a book of roadside curiosities, although Route 20 had its share, some of which are shown in later chapters. Rather, the purpose is to follow a journey across New York as closely to its original route as possible, using vintage picture postcards as illustrations. It is intended to give a glimpse of where early travelers might have stopped for gas, to eat, or to spend the night. It especially is intended to show what they would have seen along the way. The route was determined by following travel guides and road maps from the 1920s to the 1940s as accurately as possible and extrapolating information from them to current streets and roads. Whenever possible, local knowledge of the route was included. The postcards show main streets, service stations, diners, tourist homes, cabin courts, and early motels. Notable scenic and historic locations along the route also are included. Unless noted specifically in the text, all scenes in this book were located directly on historic Route 20 or could be viewed by a person traveling by automobile on the highway. In many instances they still exist, although not necessarily serving their original purpose. The overall objective was to provide a guide for anyone wishing to replicate the experience of driving across New York on Route 20 in the pre-interstate era.

In recognition of Route 20's unique qualities of scenic beauty, quaint villages, and significant contribution to transportation in New York, the 123-mile section of the highway extending from Duanesburg in Schoharie County to Lafayette in Onondaga County was designated a New York Scenic Byway in 2005.

One

THE LEBANON VALLEY

Route 20 crossed Lebanon Mountain from Massachusetts on the Lebanon Trail, established in 1916 as part of the Pittsfield-Albany toll road, which in turn was a component of the Boston to Albany Turnpike built in 1800. This strategic location, connecting New England to New York and points west was vital in the selection of this road when Route 20 was designated a federal highway in 1926.

The early traveler was immediately struck by the beauty of the valley below. Formed by the convergence of the Berkshires and the Taconic Mountains to the east and the Catskills to the south, the terrain was characterized by lush fields, rolling hills, and quaint villages, which presented a picture of serenity and comfort that had characterized the valley for decades.

Route 20 went sequentially through several small villages, all of which contain Lebanon in their names. Originally these villages were populated largely by members of the Shaker religious sect that flourished in eastern New York during the 19th and early 20th centuries. The Shakers were founded by charismatic English-born Ann Lee (1736–1784), who immigrated to America in 1774 and attracted sufficient followers to establish a dynamic religious community. They were among the largest and most successful of the utopian communal societies of the day. Shaker settlements were located near Albany, with the village of Mount Lebanon being home to the Central Ministry for America's Shakers from 1787 to 1947. At its peak, the New York Shakers claimed a population of over 600 members. They owned over 6,000 acres of land and 100 domestic and farm buildings. Modernization of agricultural methods during the first half of the 20th century and the naturally declining population of the celibate community marked the demise of the Shakers. Their remaining farmland and buildings in New York State were sold in 1947, but the Mount Lebanon Shaker Village has been designated a national historic landmark, and the site is now a museum and a school.

From the Lebanon Valley, Route 20 continued northwest through Rensselaer County. The area gradually became more metropolitan as the road approached the capital, Albany.

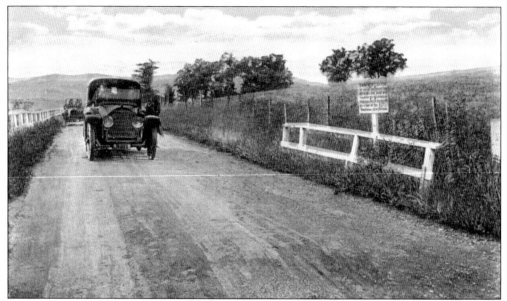

LEBANON TRAIL, NEW YORK–MASSACHUSETTS. Early motorists enjoy a drive through the picturesque countryside along the Lebanon Trail. Modern observers can only hope they were heeding the directive posted on the sign at the side of the road. It reads, "TOWN OF NEW LEBANON. Do not drive more than 20 miles per hour and observe the local ordinances. Violators will be prosecuted. By order of the Town Board, New Lebanon."

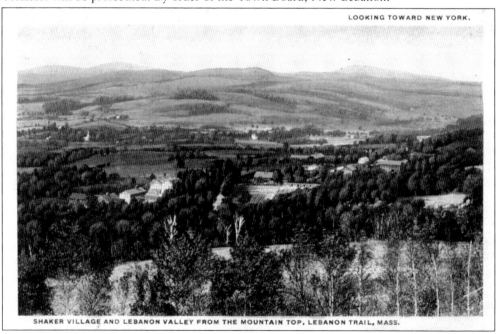

THE LEBANON VALLEY, NEW YORK. A panorama of the scenic Lebanon Valley greeted motorists as they descended Lebanon Mountain toward New York on Route 20. In this photograph, Shaker Village and the surrounding countryside are seen from the Massachusetts side of the border. Several houses and the village church can be identified. Peace, tranquility, and an agrarian lifestyle—all characteristics of Shaker communities—are evident.

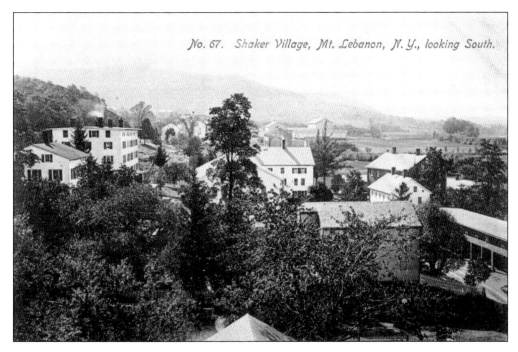

No. 67. Shaker Village, Mt. Lebanon, N. Y., looking South.

MOUNT LEBANON SHAKER VILLAGE, LEBANON TRAIL. The traditional Shaker aesthetic and philosophy of "Hands to Work—Hearts to God" are reflected in both photographs on this page. The buildings were large and utilitarian in keeping with the Shakers' communal lifestyle. They were constructed of brick, wood, stone, and shingles—all indigenous materials that were readily available and products of the land. The Shakers placed great value on daylight, and their buildings were characterized by large numbers of symmetrically placed windows.

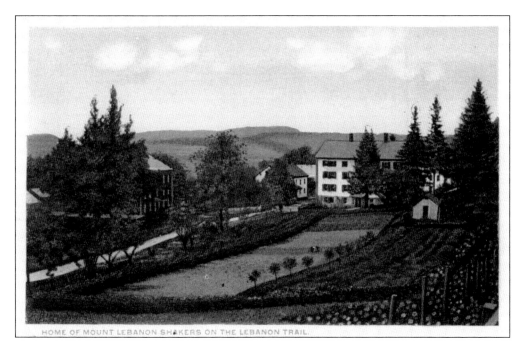

HOME OF MOUNT LEBANON SHAKERS ON THE LEBANON TRAIL.

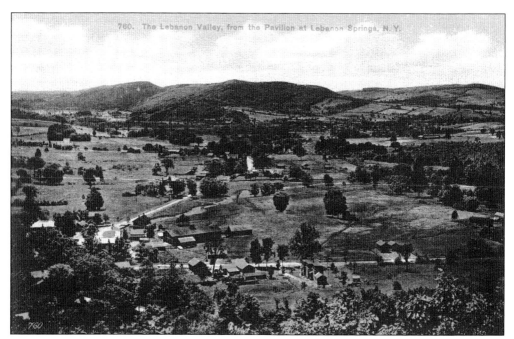

THE LEBANON VALLEY, NEW YORK. The words of Capt. Franklin Ellis in 1878 still rang true when this photograph was taken in the 1920s. He described the scene as "affording a view of indescribable beauty—a pleasing and harmonious combination of mount and vale, relieved by trees, gardens, fields, and farm-houses, with an effect that delights the eye and inspires the mind with the sublime glories of the scene."

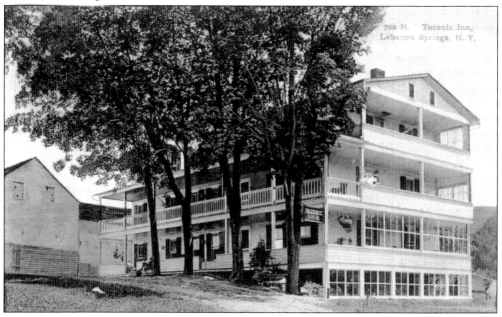

THE TACONIC INN, LEBANON SPRINGS, NEW YORK. Lebanon Springs is one the first communities in New York through which Route 20 passes after crossing the border from Massachusetts. The size and ideal location of this inn on the direct route from Springfield, Massachusetts, to Albany, New York, indicate that it was a popular stopover site for early travelers.

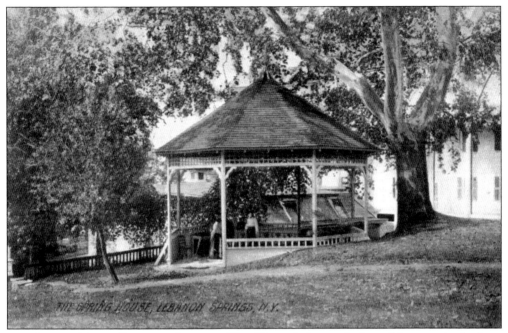

THE SPRING HOUSE, LEBANON SPRINGS, NEW YORK. Lebanon Springs did not attain the fame and elite clientele of Sharon Springs and Richfield Springs, two resort communities farther west on Route 20, but it, too, developed around naturally warm mineral springs that flowed in the community. This attractive gazebo was built around the namesake springs where local citizens and visitors could partake of the curative waters.

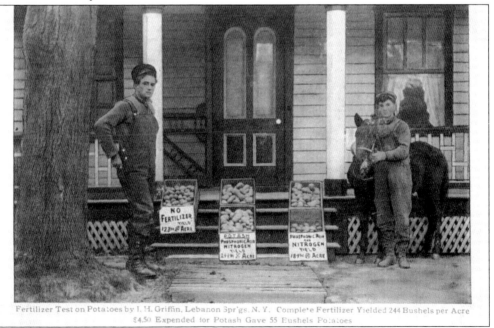

FERTILIZER TEST, LEBANON SPRINGS, NEW YORK. Two enterprising 1920s Lebanon Valley farmers demonstrate the value of fertilizer in the production of potatoes. The combination of potash, phosphoric acid, and nitrogen proved to give the best result by a wide margin.

GREETINGS FROM NEW LEBANON, NEW YORK. New Lebanon and Mount Lebanon were the same Shaker community. The names were used interchangeably, although over time Mount Lebanon become more popular. Characteristic of many small towns, New Lebanon produced postcards showing the quality of the road and attractiveness of the region. This card shows a hard-surfaced Route 20 with traffic lanes painted to assist drivers and improve the safety of the road.

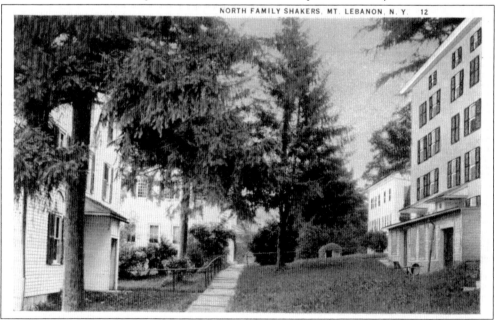

NORTH FAMILY SHAKERS, MT. LEBANON, N.Y. 12

NORTH FAMILY SHAKERS, MOUNT LEBANON, NEW YORK. The New York Shakers decreased in population during the late 19th and early 20th centuries, and many villages were forced to close. The North family were the last survivors in Mount Lebanon. Their holdings were sold in 1947, thus ending the human Shaker presence in Albany County, but 40 buildings remain giving testimony to the Shaker heritage.

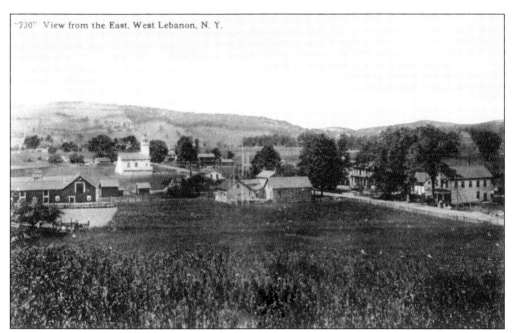

VIEW FROM THE EAST, WEST LEBANON, NEW YORK. The precursor to Route 20 can be seen going directly through the center of West Lebanon, another idyllic Shaker community in the early 1900s. By 1926, when the road was designated Route 20, and during the several decades thereafter, the region underwent a gradual shift toward a faster, more suburban lifestyle. The rural existence enjoyed by earlier residents was a victim of 20th-century progress.

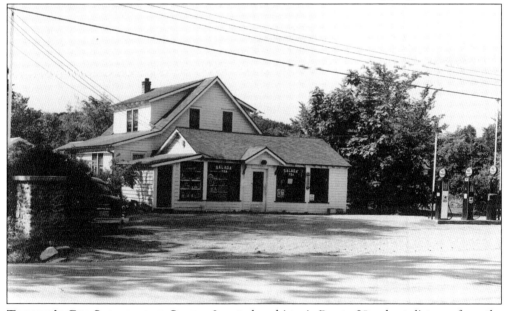

TIERNEY'S GAS STATION AND STORE. Located on historic Route 20 a short distance from the Massachusetts–New York state line, this 1940s gas station and store was that era's counterpart to the modern 7-Eleven. The three gas pumps provided Mobil gasoline, and the store featured Salada Tea products. No doubt the restroom was in the lean-to shed at the left of the building, with an outside entrance.

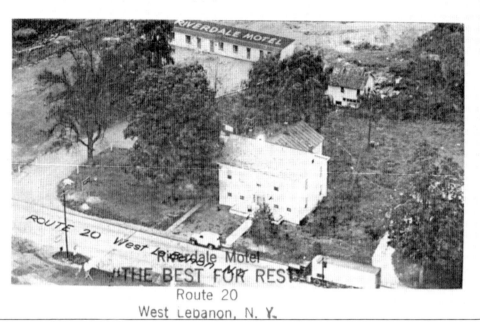

Route 20
West Lebanon, N. Y.

RIVERDALE MOTEL AND HAROLD AND ANN'S CABINS. Given the proximity and similarity between the scenes on these two postcards, it might be assumed both were taken by the same aerial photographer, possibly even on the same day. The owners of these early motels were either ahead of their time, or had an interest in aviation, as they chose this unique way to advertise their businesses. The Riverdale Motel (above) appears to be specifically targeting air travelers as the motel's name is painted on the roof of the building. "Route 20 West Lebanon" also was painted on the pavement in front of the motel. The semitrailer traffic in both photographs is confirmation that by the 1940s Route 20 had become an important commercial roadway.

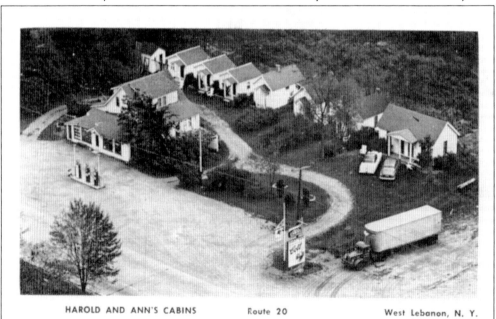

HAROLD AND ANN'S CABINS Route 20 West Lebanon, N. Y.

Two

THE CAPITAL DISTRICT

New York's Capital District refers to the four-county region surrounding the city of Albany. Route 20 passes through three of the counties—Rensselaer, Albany, and Schenectady. The highway does not pass through Saratoga County, which lies to the north. Although the district is dominated by Albany, several smaller communities, which began as individual villages and are now suburbs, provide interesting views of Route 20 and the countryside both east and west of the Hudson River.

Native Mohicans were the original inhabitants of the area. French fur traders occasionally entered the region, but permanent European settlements were not established until after 1609 when Henry Hudson claimed the territory in the name of the Dutch. In 1614, a permanent settlement named Fort Nassau was established, and a second Dutch settlement, Fort Orange, was created in 1623. Also in 1609, Samuel Champlain claimed the territory for France. Conflicts over control of the territory lasted more than 100 years, with the Dutch and French both seeking dominance. As England expanded its influence in the colonies, it also entered the fray and in 1664 seized control of both Fort Nassau and Fort Orange, eliminating those names with the singular designation Albany. The city received its official charter from England in 1686, making it the oldest continuously chartered city in the United States. Albany retained its preeminence following the American Revolution and has been the permanent capital of the state of New York since 1797.

Albany is the only major metropolitan area in New York through which Route 20 passes. Early motorists arriving from the east had spectacular views of the busy Hudson River waterfront, downtown Albany, and the government complex. The highway exited the city through attractive residential neighborhoods before reaching the countryside and villages to the west. Until the arrival of the Interstate Highway System in the 1950s, Route 20 was the main east–west transportation route in this section of New York. Even now it remains the favorite path of those who wish to travel at a more leisurely pace and enjoy the history and beauty of the area.

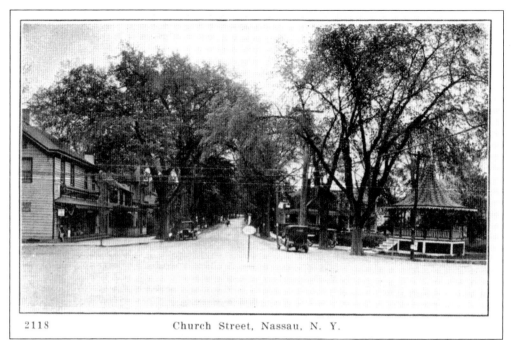

2118 Church Street, Nassau, N. Y.

CHURCH STREET, NASSAU, NEW YORK. Westbound travelers entered Nassau on this pleasant residential street and proceeded on toward the Public Square in the center of the community. This card is testimony to changes occurring in the 1920s. Three automobiles are visible in the picture, but at least one traditionalist remained in the community as a horse and buggy is coming down Church Street in the distance.

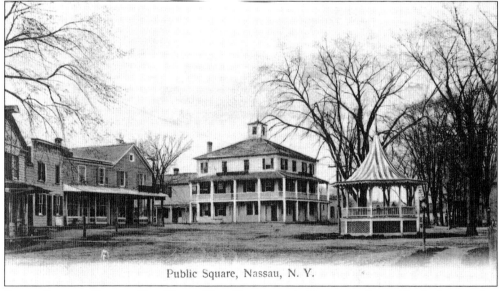

Public Square, Nassau, N. Y.

PUBLIC SQUARE, NASSAU, NEW YORK. The village green in Nassau was formed by the intersection of three streets, one of which was Church Street, the eventual Route 20. This 1920s postcard shows several homes surrounding the square. The stately building in the center is the Nassau House Hotel, said to have been built in 1800. It was torn down in 1955. No doubt the gazebo provided the stage for community band concerts.

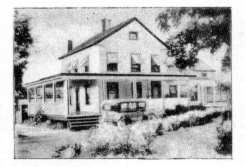

BEST 50c DINNER FROM COAST TO COAST

HACKER'S
NASSAU, N. Y.
Box 45, on Route
U. S. 20. Showers in
each cabin.
Tel. Castleton 84-J

HACKER'S
CABINS,
GAS STATION
and
RESTAURANT
10 miles east of
Albany, 4 miles west
of Nassau.

HACKER'S CABINS, GAS STATION, AND RESTAURANT. The promise of "Showers in each cabin" and the "BEST 50¢ DINNER FROM COAST TO COAST" would have made this tourist camp hard to pass by.

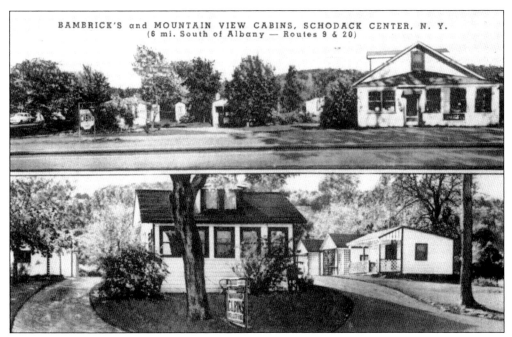

BAMRICK'S AND MOUNTAIN VIEW CABINS. There is no indication if the two tourist camps shown on this card were owned by the same person, or if their separate owners simply decided to share advertising expenses since they were located very close to each other.

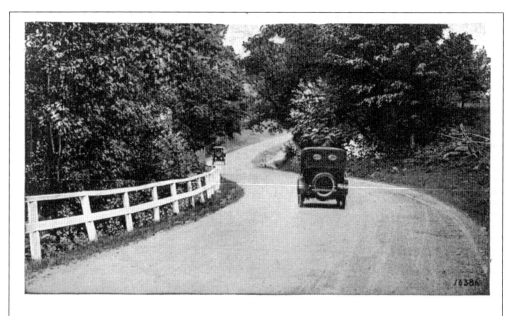

GREETINGS FROM EAST GREENBUSH, N. Y.

GREETINGS FROM EAST GREENBUSH, NEW YORK. East Greenbush was another Route 20 community that used picture postcards to promote its position on the new federal highway and the beauty of the surrounding countryside. Both objectives were fulfilled in this view. Gravel was the state-of-the-art roadbed for many sections of Route 20 during its early years. The gentle curves and rolling hills showcased the beautiful roadside foliage.

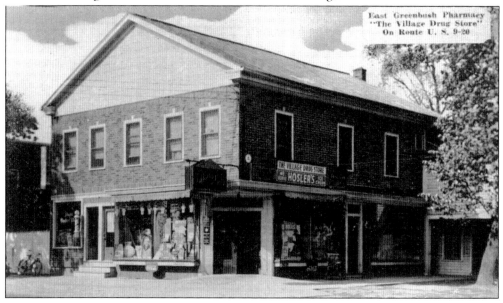

THE VILLAGE DRUG STORE, EAST GREENBUSH, NEW YORK. Route 20 was the main thoroughfare through Rensselaer County. The local name for the road in this section was the Columbia Turnpike. The Village Drug Store in East Greenbush was prominently located to meet the pharmaceutical needs of local citizens and travelers alike. They could even get a haircut at the barbershop at the left of the building.

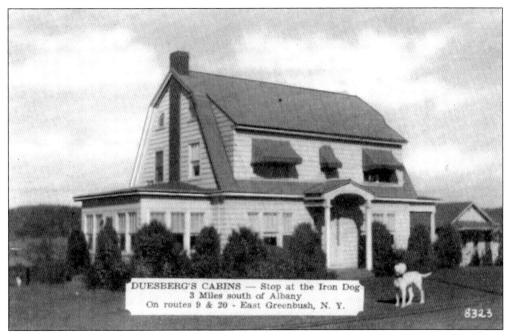

DUESBERG'S CABINS, EAST GREENBUSH, NEW YORK. Tourists were encouraged to "Stop at the Iron Dog," which was located on the front lawn of this cabin camp. Judging from the dog's size, they would have no trouble identifying the place.

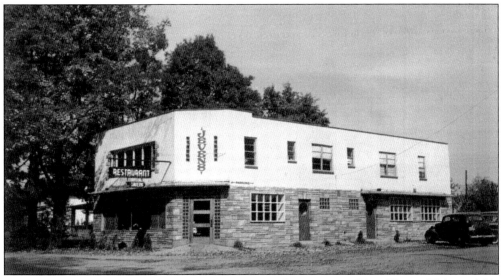

JEVENS RESTAURANT AND COCKTAIL BAR, EAST GREENBUSH, NEW YORK. This roadside establishment catered more to the local population, although travelers on Route 20 were always welcome to enjoy its "Famous Home Cooking." The caption on the back of the card tells that Jevens hosted wedding parties and banquets and was the meeting place for the Kiwanis Club every Tuesday night at 6:15 p.m.

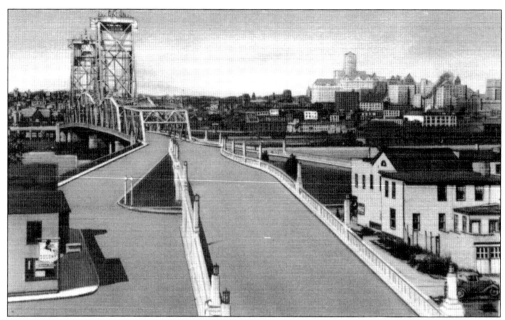

THE NEW DUNN MEMORIAL BRIDGE. This bridge was officially named the Parker F. Dunn Memorial Bridge. Connecting Rensselaer and Albany over the Hudson River, it is the eastern gateway to New York's capital city. The upper postcard shows the approach to the bridge with a view of Albany in the distance. The large, white, red-roofed building on the right side of the card is the New York State Capitol. The bridge (below) honors Pvt. Parker Dunn, a native of Albany who was killed in action in World War I when he volunteered to carry a message from his unit to another across enemy lines. Private Dunn was awarded the Congressional Medal of Honor in recognition of his valor. Route 20 traffic traveled over this bridge from 1926 until 1969 when it was replaced by the still "newer" Dunn Memorial Bridge.

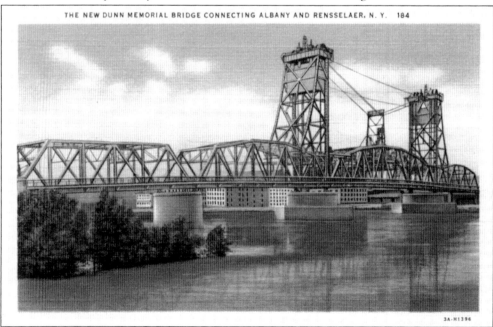

THE NEW DUNN MEMORIAL BRIDGE CONNECTING ALBANY AND RENSSELAER, N. Y. 184

3A-H1396

22

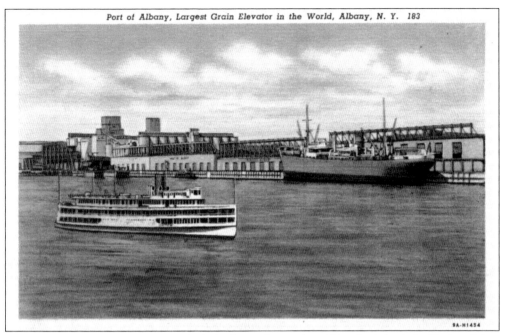

Port of Albany, Largest Grain Elevator in the World, Albany, N. Y. 183

PORT OF ALBANY, NEW YORK. Despite being located more than 150 miles inland, the Hudson River enabled Albany to be an active port capable of handling large ships. Motorists crossing the Dunn Memorial Bridge had an unobstructed view of the maritime activity on the river below.

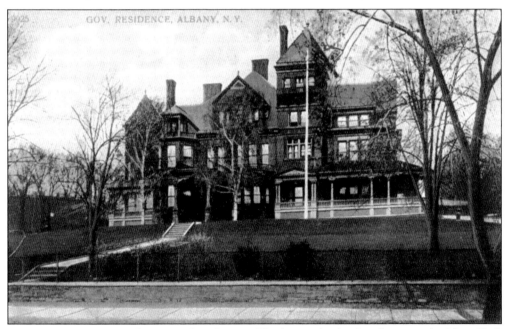

GOV. RESIDENCE, ALBANY, N.Y.

EXECUTIVE MANSION, ALBANY NEW YORK. The house destined to become the New York Executive Mansion was constructed in the 1850s by wealthy banker Thomas Olcott. The first New York governor to occupy the house was Samuel Tilden, who rented the house from its second owner, Robert L. Johnson. In 1877, the state purchased the property from Johnson for use as the permanent New York Executive Mansion.

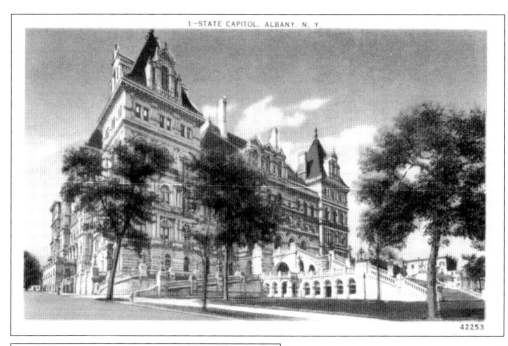

42253

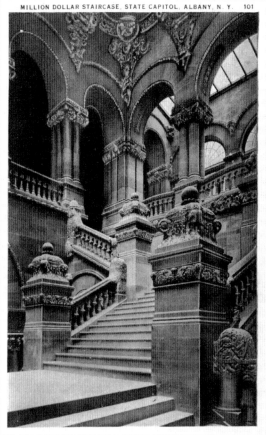

MILLION DOLLAR STAIRCASE, STATE CAPITOL, ALBANY, N.Y. 101

STATE CAPITOL, ALBANY, NEW YORK. Ground for this building was broken on December 9, 1867, and the building was completed in 1898, at a cost of nearly $25 million. The gigantic structure, constructed of gray Maine granite with red capped towers, is 300 feet north-south and 400 feet east-west, covering an area of 3 acres. The New York Capitol ranks among the most remarkable public buildings in the country.

MILLION DOLLAR STAIRCASE, ALBANY, NEW YORK. Within the Capitol building the Great Western Staircase, also known as the Million Dollar Staircase, is claimed to be the most beautiful in the world. Actually costing nearly $2 million, it rises 119 feet and took 13 years to complete. The staircase pillars contain 77 sculpted faces, most of famous Americans, but several of ordinary citizens who are referred to as the "Capitol Unknowns."

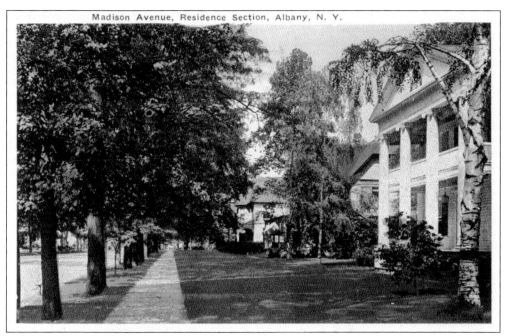

MADISON AVENUE RESIDENTIAL SECTION. Route 20 continued west in Albany following Madison Avenue through pleasant residential neighborhoods. The stately homes, mature trees, and well-trimmed lawns were testimony to the affluence of this section of the city. The sender of this postcard said she wishes the friend to whom she was writing "could be with us on some of our lovely drives. The scenery is all so beautiful."

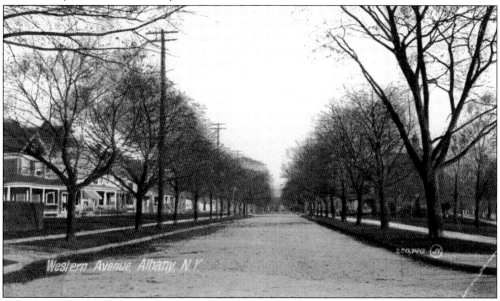

WESTERN AVENUE. Madison Avenue became Western Avenue as it approached Albany's western city limits. Here the homes were attractive but less elaborate than those on the previous card. Most homes of the day had a large front porch where residents could relax and cool off before the advent of air-conditioning. Although sidewalks were in place, the roadbed still was gravel and curbs had not been installed.

CABINS AT THE RED BRICK HOUSE, GUILDERLAND, NEW YORK. The proprietors of this tourist court put considerable effort into providing a pleasant garden-like setting, but the attraction featured most prominently on the back of the card was its hot and cold showers! There is no mention of the significance of the Red Brick House. Possibly it was simply the home of the owners, or a local landmark nearby.

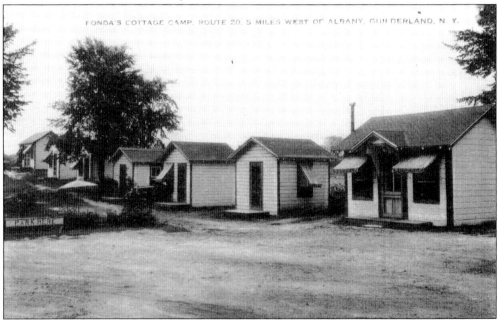

FONDA'S COTTAGE CAMP, GUILDERLAND, NEW YORK. Despite the fact that no amenities were mentioned as being available, at least one tourist driving an early 1930s automobile had chosen to stop at this location. He preferred to park by his cabin rather than heeding the "Park Here" sign.

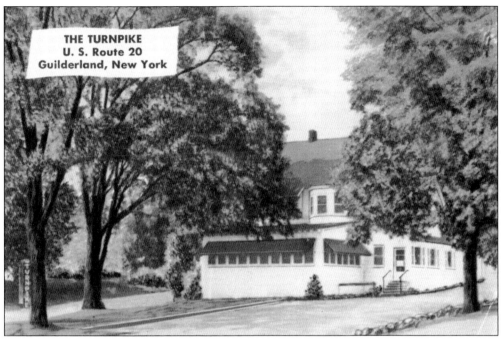

THE TURNPIKE
U. S. Route 20
Guilderland, New York

THE TURNPIKE, GUILDERLAND, NEW YORK. The back of this card reports that the Turnpike was in its 15th year of operation, dating it at least to the 1940s. The Turnpike was open from April to November, and all legal beverages were available. Guilderland was the home of Henry Rowe Schoolcraft, famous geologist, explorer, and author, who is credited with discovering the source of the Mississippi River at Lake Itasca in northern Minnesota.

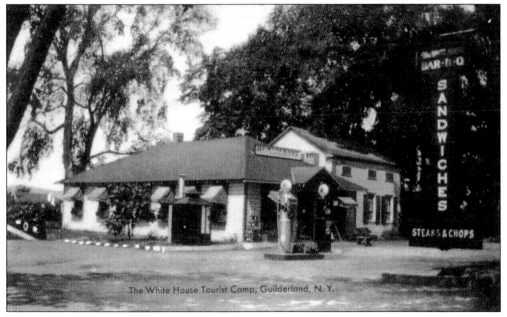

The White House Tourist Camp, Guilderland, N. Y.

THE WHITE HORSE TOURIST CAMP, GUILDERLAND, NEW YORK. Texaco products and sandwiches were featured at this 1930s gas station located on Route 20 a few miles west of Albany. Travelers also could enjoy Bar-B-Q or steaks and chops, or spend the night in the tourist cabins on the site.

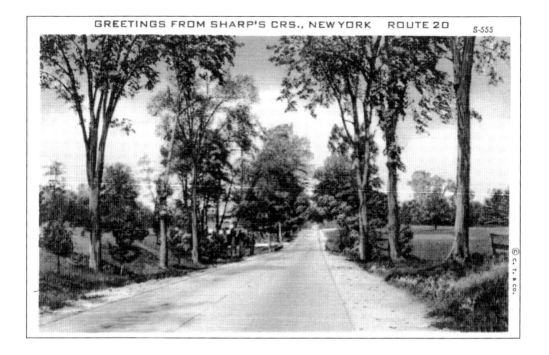

SHARP'S CORNERS, NEW YORK. Sharp's Corners appeared on early New York road maps near the junction of State Routes 146 and 158, approximately 2 miles west of Guilderland. At that time, Route 20 was a scenic, tree-lined road (above) passing through the rural countryside. A two-pump service station and cabin camp (below) appear to be the extent of its commercial district. Like hundreds of similar crossroads towns, over the ensuing years Sharp's Corners fell victim to urban sprawl and it no longer is identifiable as a unique community.

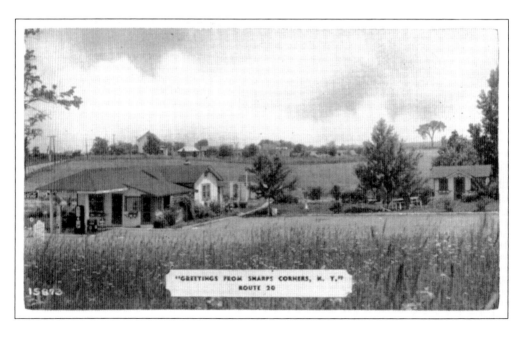

"GREETINGS FROM SHARPS CORNERS, N. Y."
ROUTE 20

LaPorte's Motel and Cabins, Route 20, Duanesburg, New York. Even in this early era of hard-surfaced highways, Route 20 was beginning to show its age and the effects of heavy traffic. Deteriorating concrete and the resulting repairs are clearly evident on this stretch of the road.

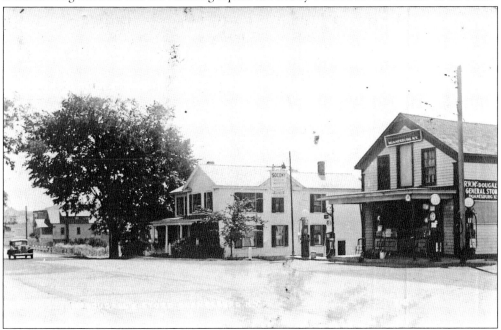

R. W. McDougall General Store, Duanesburg, New York. Duanesburg appears to have been an idyllic rural community in eastern New York. No doubt this typical general store supplied the basic needs of the local population. The placement of gas pumps directly on the street in front of a business was common in the 1930s, although most did not have four pumps as are shown here.

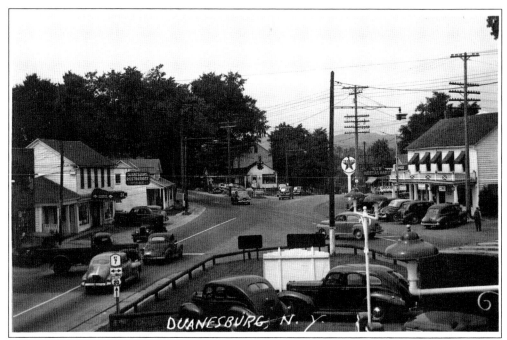

JUNCTION OF ROUTE 20 AND NY 7, DUANESBURG, NEW YORK. Duanesburg proclaimed itself to be "The Town You'll Remember" and was a bustling community in the 1930s. This view, looking west, shows a Route 20 sign in the foreground. The directional signs at the intersection point to Syracuse straight ahead and Binghamton to the left. The Hub Restaurant is seen on the right.

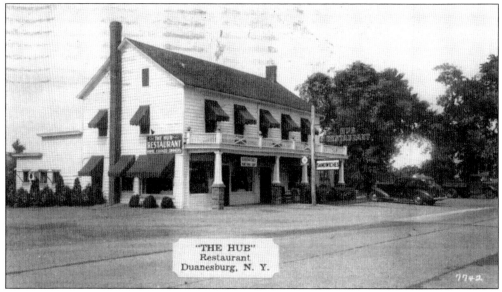

THE HUB RESTAURANT, DUANESBURG, NEW YORK. This building, originally the Case Hotel and Tavern, dates to the Revolutionary War and served as a stagecoach stop. During the Civil War, residents gathered here for the reading of the war news. For many years, the town offices and the post office were located in the Case Tavern and town officials were elected at annual meetings held in the tavern's hall.

Three

THE GREAT
WESTERN TURNPIKE

In 1799, the New York Legislature appointed a committee to plan the Great Western Turnpike, which was to extend from Albany to the frontier village of Cherry Valley. The committee's charge was to ease the rigors of commercial and personal travel in the westward direction. The committee worked efficiently, and within a short time, the First Great Western Turnpike was in operation. Subsequently, the Second and Third Great Western Turnpikes were completed, the former going south from Cherry Valley through Cooperstown and on to Sherburne, New York. The Third Great Western Turnpike, more commonly called the Cherry Valley Turnpike, continued west from Cherry Valley through the Finger Lakes region and terminated near Syracuse. The First and Third Great Western Turnpikes were incorporated into Route 20 in 1926 thereby bringing two of the state's most historic and certainly most scenic highways into the Federal Highway System.

By the time Route 20 was formed, the Great Western Turnpike had been a popular road for more than 100 years. Travelers found a robust economy along its entire route. Successful villages had evolved from the early taverns and stagecoach stations that lined the road. These communities assured travelers that shelter, food, and other amenities would be available. The Great Western Turnpike had the added advantage of being the location of the famous resort at Sharon Springs, which had attracted wealthy easterners to its curative mineral springs since the middle of 19th century. Although average citizens could not afford the luxury of the hotels in these resorts, they took advantage of the more modest accommodations that sprang up nearby.

A drive along the Great Western Turnpike was a treat for early motorists. Both sides of the road were flanked by rolling farmland, sparkling lakes and streams, and several old growth forests. Each of the communities along the road could make a legitimate claim to its success. Their quaint main streets, historic sites, and especially the different architectural styles of the homes reflected the range of tastes and nationalities of the populations that had occupied the area over the years.

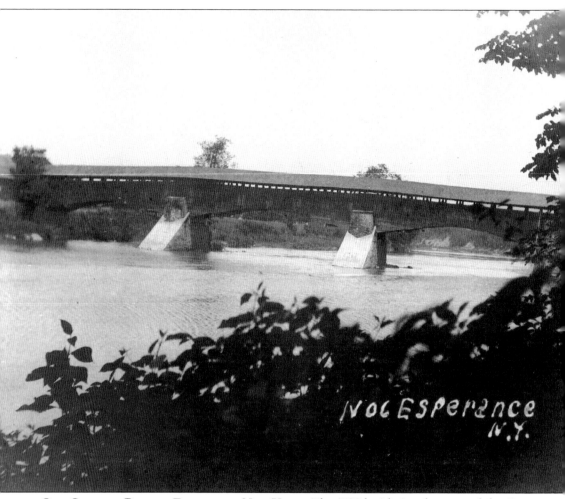

OLD COVERED BRIDGE, ESPERANCE, NEW YORK. The 1799 legislation that created the Great Western Turnpike Committee specifically called for the planning and construction of a new toll bridge over Schoharie Creek to replace a bridge that had been washed away by a flood. The three-span wooden bridge shown in this picture was the result. The covered bridge was designed and built by Theodore Burr, who was a cousin of Vice Pres. Aaron Burr. It was officially opened on January 1, 1812. Theodore Burr was an accomplished, skilled engineer and was responsible for several significant bridges in New York in the early 1800s. He is especially remembered for developing the Burr Truss support system, which became the standard for bridge construction throughout the 19th century. When the Esperance bridge was replaced in 1930, it was the last of the Burr-designed bridges in the country.

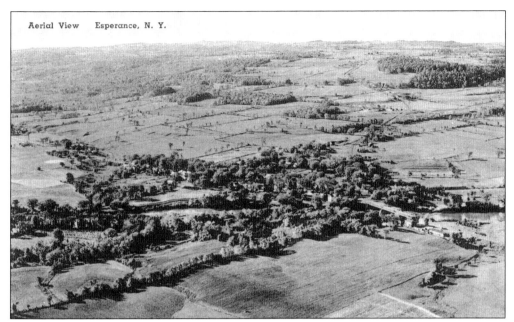

Aerial View Esperance, N. Y.

AIR VIEW, ESPERANCE, NEW YORK. Route 20 is seen running from left to right in the center of this card, directly through the small village of Esperance. The bridge over Schoharie Creek, the demarcation between Schenectady and Schoharie Counties, can be seen in the right center of the picture. This bridge replaced the famous covered bridge shown in the picture on page 32.

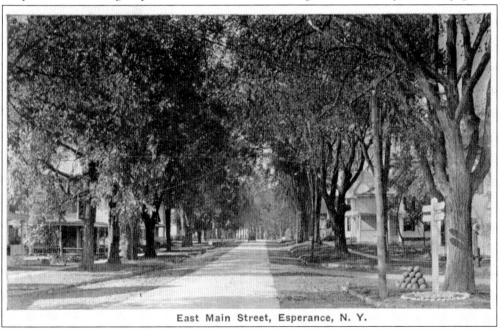

East Main Street, Esperance, N. Y.

EAST MAIN STREET, ESPERANCE, NEW YORK. This card was mailed in 1927, one year after Route 20 became a federal highway. The scene is of the prototypical small town of the day. Main Street was narrow and flanked by stately trees and beautiful homes, most of which had large, inviting front porches. The cannonballs and white marker in the lower right corner were probably a memorial to an event important to the community.

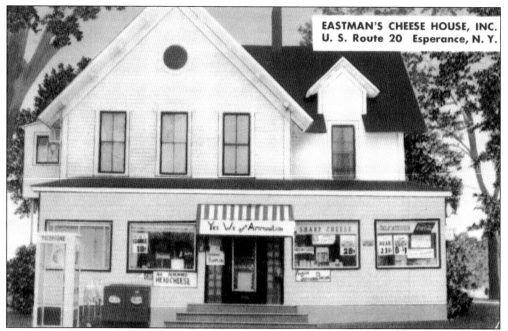

EASTMAN'S CHEESE HOUSE, INC.
U. S. Route 20 Esperance, N. Y.

EASTMAN'S CHEESE HOUSE, ESPERANCE, NEW YORK. This classic example of a 1930s mom-and-pop convenience store had the business structure added onto the proprietor's home. The store featured corn cob smoked bacon and imported and domestic cheeses. Travelers were assured that Eastman's would ship products anywhere in the United States. The "Yes We Have Ammunition" sign indicates that hunting was popular in this region of New York.

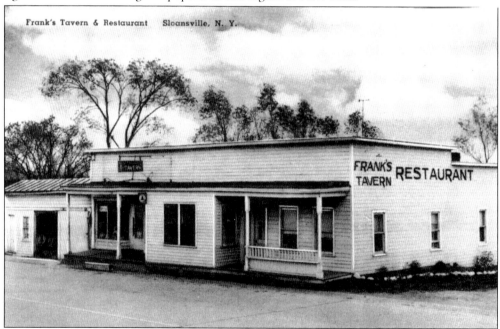

Frank's Tavern & Restaurant Sloansville, N. Y.

FRANK'S TAVERN AND RESTAURANT, SLOANSVILLE, NEW YORK. Hungry or thirsty travelers who passed through Sloansville could take advantage of Frank's straightforward approach to business. His slogan was simply "Good Food—All Legal Beverages."

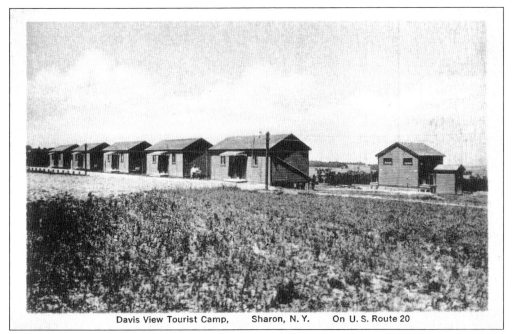

Davis View Tourist Camp, Sharon, N. Y. On U. S. Route 20

DAVIS VIEW TOURIST CAMP, SHARON, NEW YORK. This postcard is undated, but it must show one of the very early tourist camps along Route 20. In spite of its lack of amenities, including shade, it appears to have at least one guest, or possibly the gentleman in the picture is the manager just taking a break. Restroom facilities were in the outbuilding at the right.

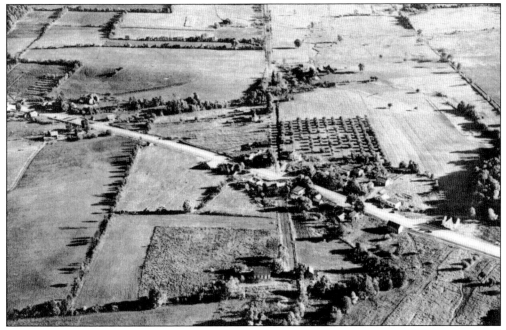

AIR VIEW, SHARON HILL, NEW YORK. Route 20 runs from left to right through this rural New York village. The service station and church shown in the following card are visible on the right side of this picture.

35

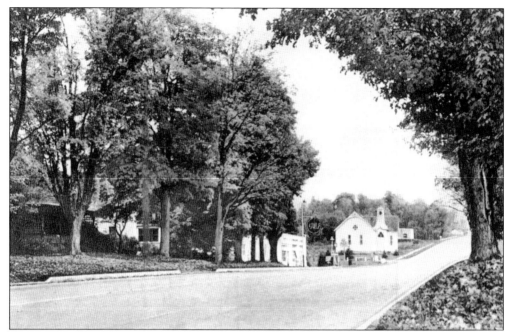

ROUTE 20, SHARON HILL, NEW YORK. This scene showing Route 20 as it leaves Sharon Hill is characteristic of hundreds of small towns throughout the country. The pleasant residential street, local service station, and the community church are all icons of rural America.

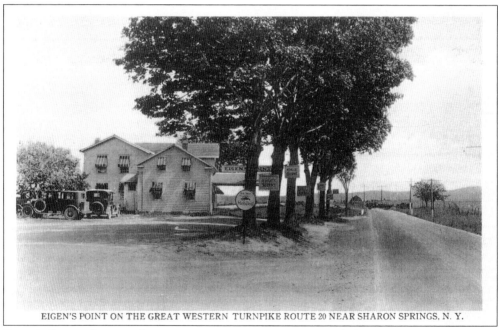

EIGEN'S POINT ON THE GREAT WESTERN TURNPIKE ROUTE 20 NEAR SHARON SPRINGS, N. Y.

EIGEN'S POINT, SHARON SPRINGS, NEW YORK. No tree was safe from a sign at Eigen's Point Tourist Home in the 1920s. The signs read from closest to most distant: "Mobiloil" (on the post), "Ala Carte Service," "Home-Like Cuisine," "Restrooms," and "Fresh Salads." The last two signs are unreadable.

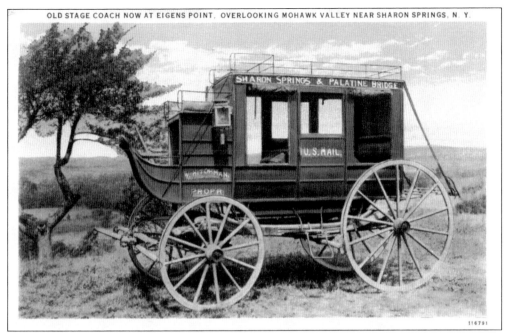

OLD STAGECOACH, SHARON SPRINGS, NEW YORK. An antique stagecoach was an added attraction for persons who stopped at Eigen's Point. Information on the back of the card says that it plied the course between Sharon Springs and Palatine Bridge 50 years earlier. The coach had an elegant but confining passengers' compartment, baggage racks on the top and behind, and a mail pouch recess under the driver's seat.

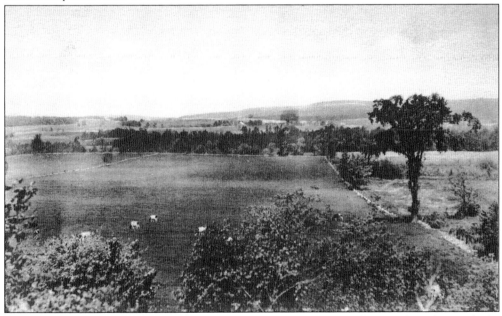

VIEW FROM EIGEN'S POINT, SHARON SPRINGS, NEW YORK. As illustrated on this card, the scenery along the Great Western Turnpike during the early years of Route 20 was mostly rural. The small villages through which the road passed did little to interrupt views of the idyllic countryside. In this photograph, several cows graze in a pasture beside a narrow country lane.

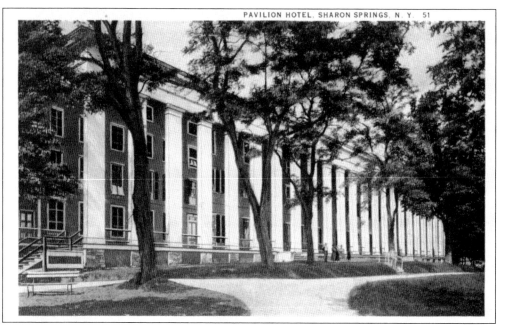

PAVILION HOTEL, SHARON SPRINGS, NEW YORK. Built in 1842, the Pavilion was the first of the impressive luxury hotels to attract wealthy socialites to Sharon Springs's famous sulphur springs. It quickly rose to the status of seasonal destination for such luminaries as the Vanderbilts, Van Rensselaers, and Oscar Wilde. The Pavilion Hotel weathered both the highs and lows of Sharon Springs's fortunes for 100 years before inevitably losing its glitter. The hotel was demolished in 1941.

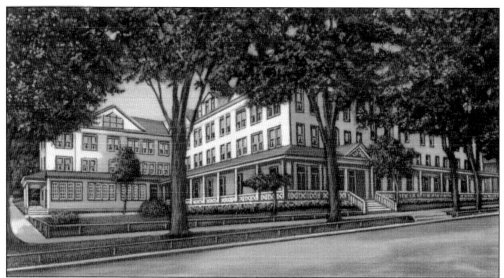

ROSEBORO HOTEL, SHARON SPRINGS, NEW YORK. The Roseboro Hotel open in 1900 by merging three separate hotels. It had 135 rooms, the first sprinkler system in the community, and in 1939 an Otis elevator. The Roseboro entertained thousands of guests fleeing the summer heat of the city and escaping to the town's minerals spas. Later interest in the baths declined, and the hotel closed in 1968. In 1996, it was purchased, renovated, and reopened. The Roseboro is on the National Register of Historic Places.

38

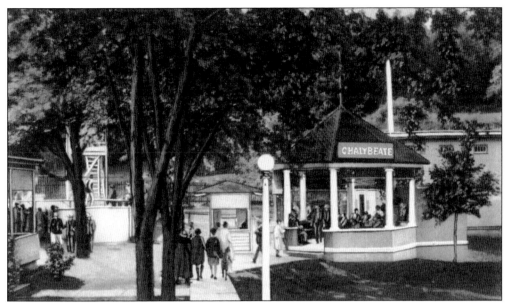

CHALYBEATE SPRINGS, SHARON SPRINGS, NEW YORK. From the 16th century, chalybeate (iron containing) water was a popular curative for an assortment of ailments, especially anemia. This National Register Historic site, known as the Chalybeate Temple, was built in 1910. The water was said to contain enough iron to turn one's teeth brown, but nonetheless it was bottled and sold. Patrons also could be invigorated by bathing in the adjacent swimming pool.

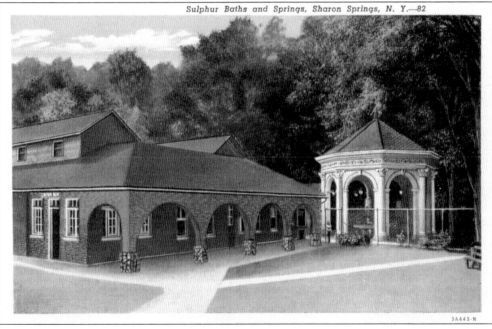

SULPHUR TEMPLE AND BATH HOUSE, SHARON SPRINGS, NEW YORK. The ornate gazebo and adjoining bathhouse were built in 1927. Resort guests could partake of the healing waters at the fountains it contained, or they could bathe in the sulphur springs in the adjacent bathhouse. In addition, inhalation therapy, whereby patients breathed the fumes of the mineral gases, was available in specially constructed rooms within the hotels and bathhouses.

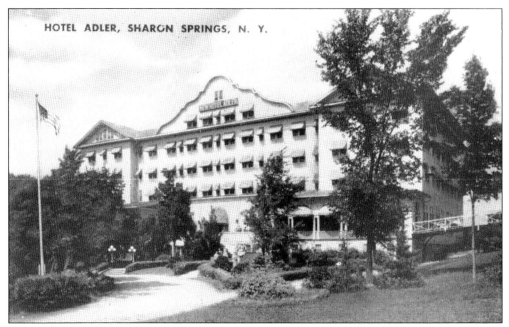

ADLER HOTEL SHARON SPRINGS, NEW YORK. The Adler was the last of the resort hotels built in Sharon Springs. It opened in 1927 and offered guests sulphur baths and treatments directly within the building. Guests also enjoyed a variety of sporting and social activities and professional entertainment. In 1946, following his release from military service, 22-year-old Ed Koch, future U.S. congressman and mayor of New York, served as a busboy at the Adler hotel.

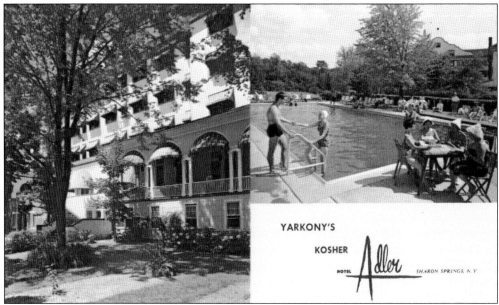

YARKONY'S KOSHER HOTEL, SHARON SPRINGS, NEW YORK. During the early 20th century, wealthy easterners were attracted to newer and more exciting destinations. Sharon Springs underwent a gradual transition into a primarily Jewish resort. Many Jews who had fled Europe patronized the old hotels, as did Jewish guests from the eastern United States. By the 1940s, all of the town's major hotels assured guests that their kitchens were kosher.

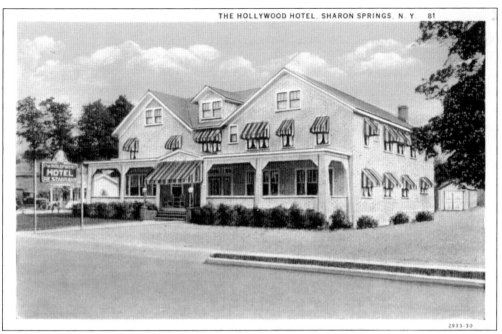

HOLLYWOOD MOTOR INN, SHARON SPRINGS, NEW YORK. This hotel did not try to compete with Sharon Springs's resort hotels. It simply was a roadhouse for travelers on Route 20, a "Truly Distinctive Country Inn That's Delightfully Different—the Weary Traveler's Place to Rest." The automobile parked behind the sign indicates that this card was published in the early 1930s.

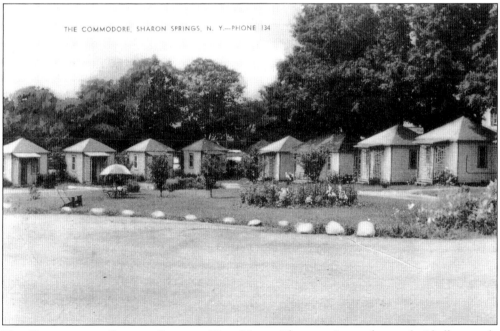

THE COMMODORE, SHARON SPRINGS, NEW YORK. The proprietors chose a decidedly upscale name for this 1930s tourist court. As indoor bathrooms were a prominent marketing feature at the time, the fact that no mention is made of this amenity probably indicates that the traditional "outhouse" was still in use.

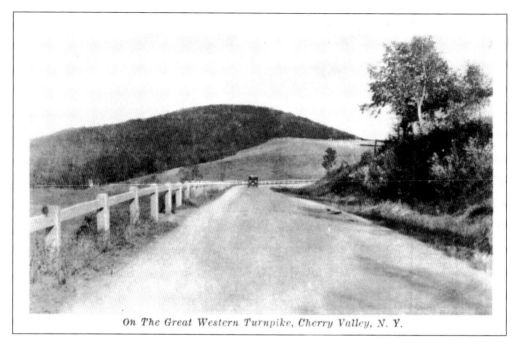

On The Great Western Turnpike, Cherry Valley, N. Y.

GREAT WESTERN TURNPIKE, CHERRY VALLEY, NEW YORK. This section of the Great Western Turnpike near Cherry Valley still had a gravel surface when the two photographs on this page were made in the 1920s. The pictures probably were taken in sequence by the same photographer as the automobile shown in the card above is oncoming, whereas in the card below it is disappearing in the distance. During the 28 years after its designation as a federal highway, Route 20 followed this road into Cherry Valley. In 1954, the road was straightened, bypassing Cherry Valley altogether.

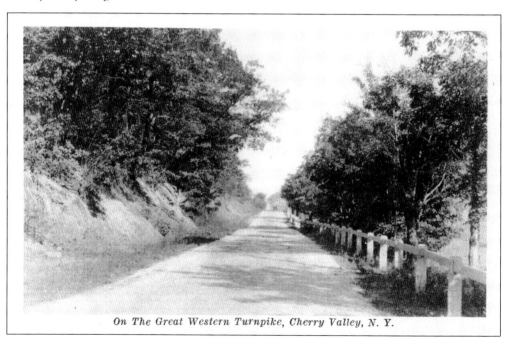

On The Great Western Turnpike, Cherry Valley, N. Y.

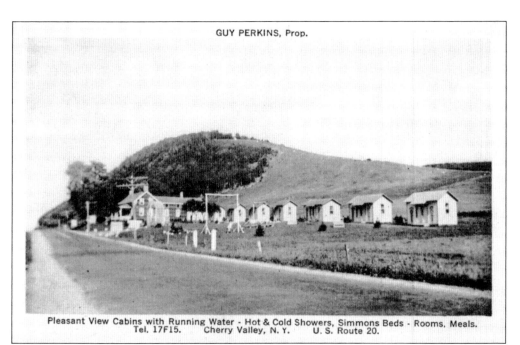

GUY PERKINS, Prop.

Pleasant View Cabins with Running Water - Hot & Cold Showers, Simmons Beds - Rooms, Meals.
Tel. 17F15. Cherry Valley, N. Y. U. S. Route 20.

PLEASANT VIEW CABINS, CHERRY VALLEY, NEW YORK. This 1930s tourist court offered an attractive rural setting. The large front lawn was equipped with a playground, and children could also explore the large hill behind the cabins. Running water, hot and cold showers, flush toilets, and Simmons beds were standard in every cabin. The name Pleasant View boasted a "100 Mile View of the Mohawk Valley."

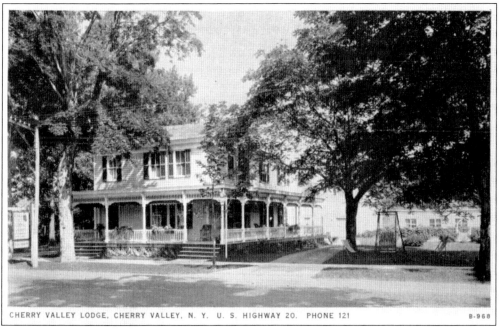

CHERRY VALLEY LODGE, CHERRY VALLEY, N. Y. U. S. HIGHWAY 20. PHONE 121 B-968

CHERRY VALLEY LODGE, CHERRY VALLEY, NEW YORK. This lodge was another private residence that had been converted to a tourist home. The inviting front porch and a swing and lawn chairs on the shaded grounds were available to guests.

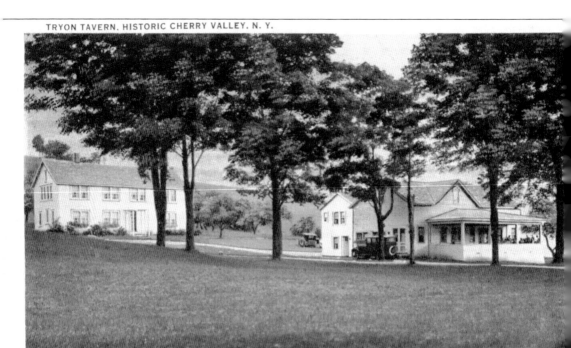

TRYON TAVERN, CHERRY VALLEY, NEW YORK. By the early 20th century, the Tryon Tavern had established itself as one of the best known inns in eastern New York. Its pleasant country setting near Cherry Valley included a large front lawn and guest rooms, restaurants, and lounges in its attractive buildings. The inn's reputation for fine dining attracted patrons for miles around, as well as motorists traveling on the Great Western Turnpike. Late-1920s-era automobiles were parked on the grounds when this picture was taken, and the writer of the card in 1935 described the Tryon Tavern as a lovely place to stay—all furnished with genuine antiques.

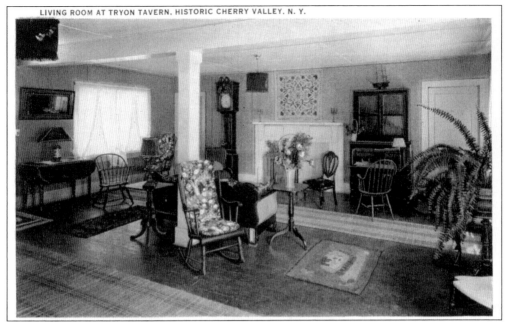

PUBLIC ROOMS, CHERRY VALLEY, NEW YORK. The Tryon Tavern's comfortable living room is shown in the photograph above. It was appointed with period furniture and provided a pleasant place for guests to gather throughout the day. The dining room, shown below, was the site of many business and social events of the day. One such meeting held by the Cherry Valley Turnpike Association confirms the role the Tryon Tavern played in the early history of Route 20. An item in the *Richfield Springs Mercury* dated January 17, 2008, reads, "75 Years Ago—October 1932: The directors of the Cherry Valley Turnpike Association elected Harry Tuller of Richfield Springs president of the association at their annual meeting held last Monday evening at the Tryon Tavern in Cherry Valley."

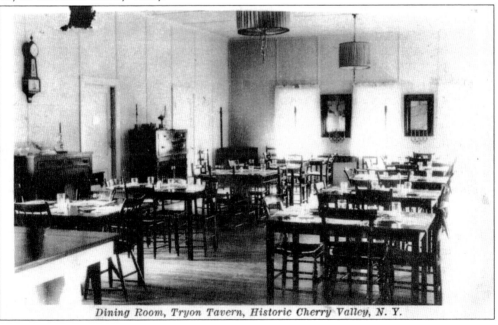

Dining Room, Tryon Tavern, Historic Cherry Valley, N. Y.

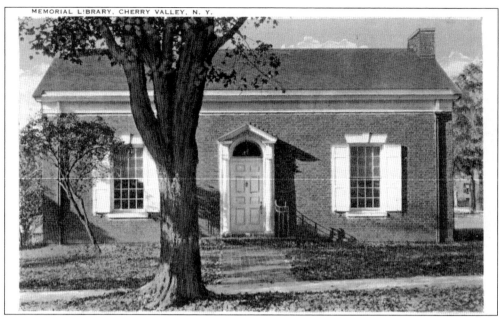

MEMORIAL LIBRARY, CHERRY VALLEY, NEW YORK. Rather than a traditional military monument, Cherry Valley chose a community library to memorialize the soldiers, sailors, and nurses who had fought in World War I. The building was formally dedicated on September 8, 1924. The library is included in the Cherry Valley Historic District, which is listed on the National Register of Historic Places.

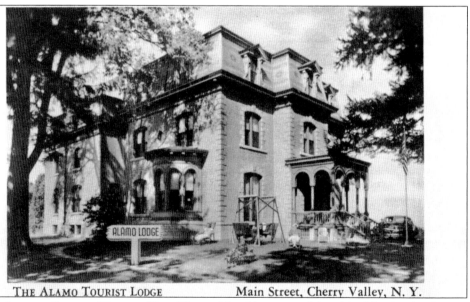

THE ALAMO TOURIST LODGE Main Street, Cherry Valley, N. Y.

THE ALAMO, CHERRY VALLEY, NEW YORK. The Alamo proclaimed itself to be the "Finest Tourist Lodge and Coffee Shop Catering to the Discriminating Tourist." The historic 1870s mansion was located in the heart of Cherry Valley. The lodge was newly decorated and furnished, offering large, light rooms, some with private baths. Despite emphasis on the lodge's history, the proprietors acceded to modernity in at least one respect. Travelers were advised to "Look for the Neon Sign."

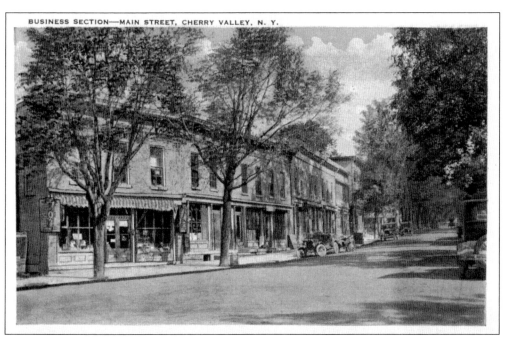

MAIN STREET, CHERRY VALLEY, NEW YORK. The two postcards on this page, taken in the 1920s and 1930s respectively, illustrate changes in Cherry Valley's Main Street. The above photograph shows a quiet street with many large trees and few automobiles. In the photograph below, the trees have been removed and the street was more dynamic. Many cars lined the street, and Esso gasoline was dispensed directly from sidewalk pumps. A significant advancement in communications technology is credited to Cherry Valley. It was here that Samuel Morse, with the help of his cousin Judge James Morse and Amos Swan, a local merchant, developed the first working telegraph machine in 1837. The invention was patented, and by 1844, it was perfected to the point that Morse and Swan established the area's first telegraph office in Cherry Valley.

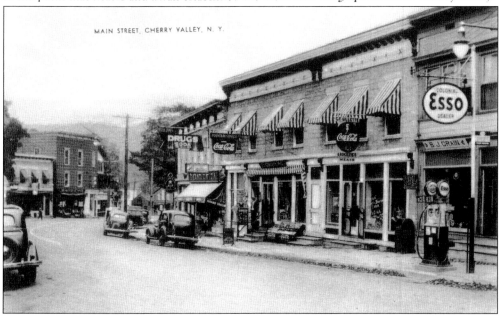

47

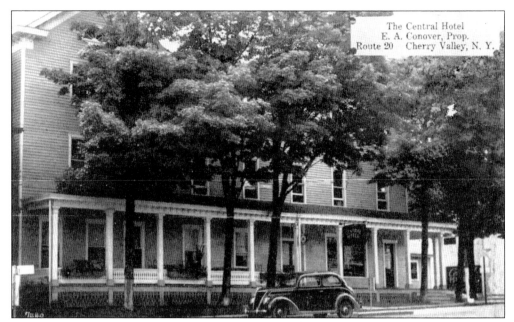

CENTRAL HOTEL, CHERRY VALLEY, NEW YORK. This large wood-frame hotel was a mainstay for early travelers on Route 20 as well as visitors in the area. No doubt the large front porch provided a pleasant place to relax in the evenings. A 1937 Ford, possibly owned by a guest, occupied a prominent position at the curb. The building was razed in the mid-1970s.

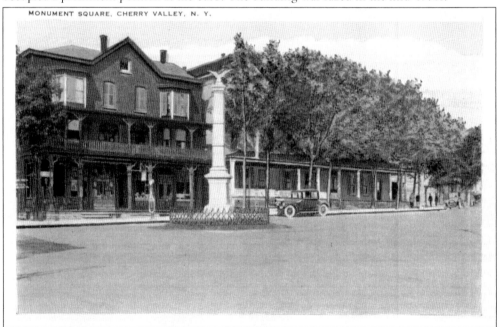

MONUMENT SQUARE, CHERRY VALLEY, NEW YORK. Westbound traffic on Route 20 proceeded along Cherry Valley's Main Street to the center of the business district before leaving to the west on Genesee Street. The focal point was Monument Square, where the Soldiers and Sailors Monument was the centerpiece. The Cherry Valley Historic District surrounds Monument Square and is listed on the National Register of Historic Places.

Four

THE CHERRY VALLEY TURNPIKE

Cherry Valley holds the distinction of being the western terminus of the First Great Western Turnpike and the eastern terminus of the Third Great Western Turnpike, which extended the road 60 miles farther west to Cazenovia. Thus, it was the connecting link of the road that opened travel to the frontier communities in central and western New York. The Third Great Western Turnpike came to be known as the Cherry Valley Turnpike, and later that name was applied to the entire road.

The Cherry Valley Turnpike was begun in 1803 and was completed in 1811. Much of the impetus for extending the road farther west came from the town of Cazenovia where leaders recognized the importance of being included on the main east-west highway across New York. Like the First Great Western Turnpike, the road had served with distinction for more than 100 years before it was incorporated into Route 20. Also, like neighboring Sharon Springs, the Cherry Valley Turnpike was home to the first-class resort community Richfield Springs, another site of curative sulphur springs.

Inclusion of the Cherry Valley Turnpike in Route 20 resulted in improvements to the road. A 1928 booklet published by the Cherry Valley Turnpike Association stated, "The road is a fine demonstration of the axiom that a straight line is the shortest distance between two points. In the 116 miles between Albany and Cazenovia, the road is hardly ever more than 5 miles from the air line between these points. Remember too, this is not flat country but reach altitudes varying between 1500 and 1700 feet, and in some places pass elevations which rise to 2,300 feet. You will marvel as you motor over the smooth surface of the road, at the long easy grades which permit travel from end to end in either direction without the need of changing gears. The reasonable speed of 30 miles per hour is convenient for both car and driver."

Ironically, in 1954, Route 20 was realigned between Sharon Springs and East Springfield, completely bypassing Cherry Valley, the turnpike's namesake city.

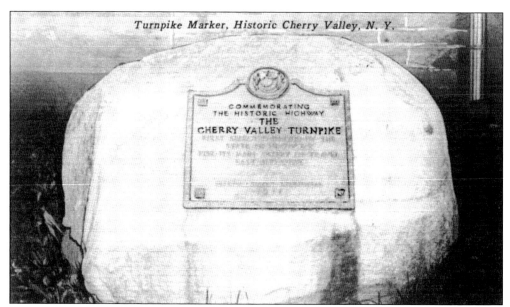

CHERRY VALLEY TURNPIKE MARKER, CHERRY VALLEY, NEW YORK. The plaque, prominently located on Main Street in Cherry Valley, was installed within one year of Route 20 being designated a federal highway. The inscription reads, "Commemorating the historic highway the Cherry Valley Turnpike. First selected in 1799 by the state of New York for its main artery of travel east and west. Erected • Sesquicentennial 1927."

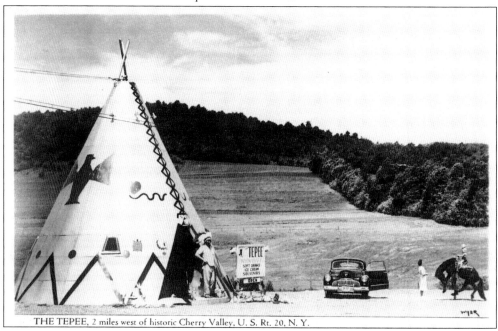

THE TEPEE, 2 miles west of historic Cherry Valley, U. S. Rt. 20, N. Y.

THE TEPEE, CHERRY VALLEY, NEW YORK. The Tepee Souvenir and Gift Shop has been a fixture on Route 20 for 60 years. It was first located approximately 2 miles west of Cherry Valley on original Route 20 (now NY54). When Route 20 was realigned to bypass Cherry Valley, the owners moved the business to the present location where it remains one of the highway's most recognized attractions.

50

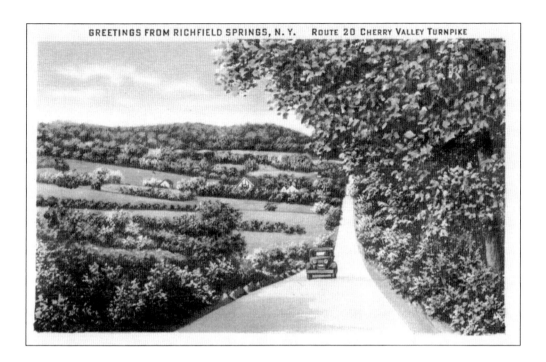

GREETINGS FROM RICHFIELD SPRINGS, N.Y. ROUTE 20 CHERRY VALLEY TURNPIKE

THE CHERRY VALLEY TURNPIKE BETWEEN CHERRY VALLEY AND RICHFIELD SPRINGS, NEW YORK. It is easy to understand why Route 20 was, and continues to be, one of New York's most popular roads for motorists looking for beautiful scenery. The two cards on this page were produced in the 1930s. Both the above and below views show verdant fields, rolling hills, and well-maintained farmsteads. The lake in the card below is an added attraction.

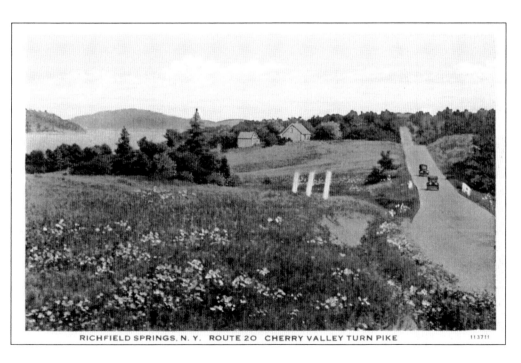

RICHFIELD SPRINGS, N.Y. ROUTE 20 CHERRY VALLEY TURN PIKE 113711

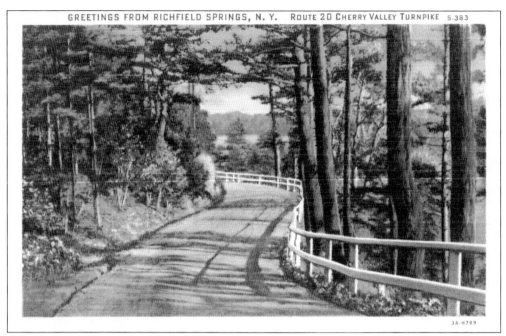

GREETINGS FROM RICHFIELD SPRINGS, NEW YORK. The beauty of the countryside continued throughout the entire distance of the Cherry Valley Turnpike between Cherry Valley and Richfield Springs. In this early photograph, the road surface was still gravel. The attractive white fence helped guide motorists along the road, especially at night.

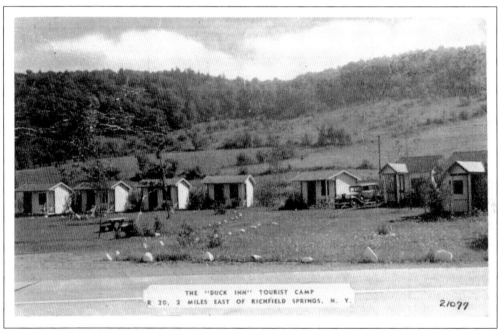

THE DUCK INN TOURIST CAMP. The proprietor of this early-1930s tourist camp probably was proud of its clever name. Guests could enjoy the front lawn where chairs and a picnic table were provided, or they might hike in the forested hills in the distance.

FOUNTAIN VIEW MOTEL. Situated on a quiet hillside, every room in this early motel had a view of Richfield Springs's reservoir and its illuminated fountain. The motel was equipped with flush toilets and showers, and it was only a short 15-20 minute drive from Cooperstown and the Baseball Hall of Fame.

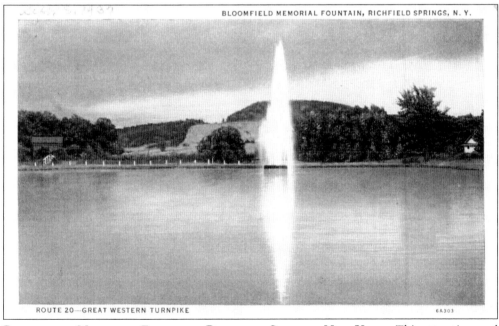

BLOOMFIELD MEMORIAL FOUNTAIN, RICHFIELD SPRINGS, NEW YORK. This attractive card shows the famous illuminated fountain that was a landmark in Richfield Springs. It was located in the reservoir at the eastern edge of the city. This card was never mailed, but the date penciled in the upper left margin, September 8, 1937, probably indicates the day the original owner of the card passed through the community.

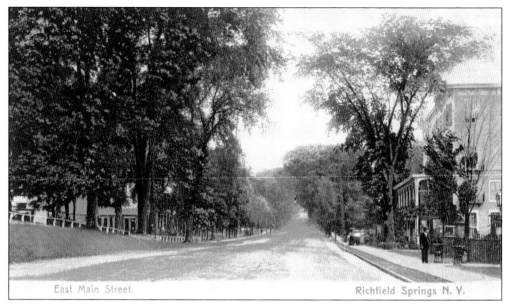

East Main Street. Richfield Springs N. Y.

EAST MAIN STREET, RICHFIELD SPRINGS, NEW YORK. Westbound travelers on Route 20 entered Richfield Springs on this pleasant tree-lined street bordered on both sides by large homes and well-manicured lawns. One of the city's many tourist hotels is shown on the right side of the card. This entire section is part of Richfield Springs's East Main Street Historic District and is on the National Register of Historic Places.

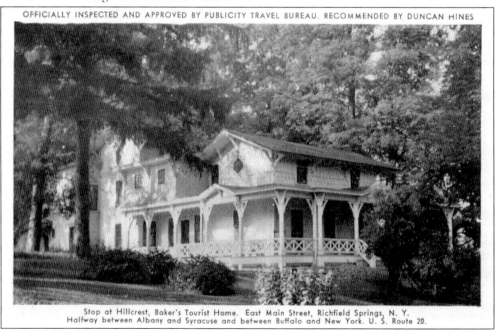

OFFICIALLY INSPECTED AND APPROVED BY PUBLICITY TRAVEL BUREAU. RECOMMENDED BY DUNCAN HINES

Stop at Hillcrest, Baker's Tourist Home. East Main Street, Richfield Springs, N. Y.
Halfway between Albany and Syracuse and between Buffalo and New York. U. S. Route 20.

HILLCREST, BAKER'S TOURIST HOME, RICHFIELD SPRINGS, NEW YORK. The writer of this card in 1941 said she had stayed here the night before and it was a very nice place. She went on to say that their trip had been lovely. No point of origin was given, but she said they were traveling "The Cherry Valley Route" to Boston and hoped to arrive there the following afternoon, a distance of approximately 250 miles.

Sulphur Spring Fountain, Richfield Springs, N. Y.

SULPHUR SPRINGS FOUNTAIN, RICHFIELD SPRINGS, NEW YORK. For centuries, the site of this Great White Sulphur Spring was carefully guarded by the Canadarago Indians, who were well aware of the curative powers of its water, but inevitably as white settlers moved westward, the spring was discovered. It opened to the public in 1870, and by 1886, eighteen distinct mineral springs had been identified in and near the village. Most contained sulphur as their primary element but they varied in their elemental content. Richfield Springs evolved into a first-class resort frequented by the social elite of the day. Theodore Roosevelt visited Richfield Springs in 1883 to recover from an attack of asthma. The marker at the lower right of the fountain reads, "Erected 1831 by Andwauces Chapter DAR Richfield Springs, New York."

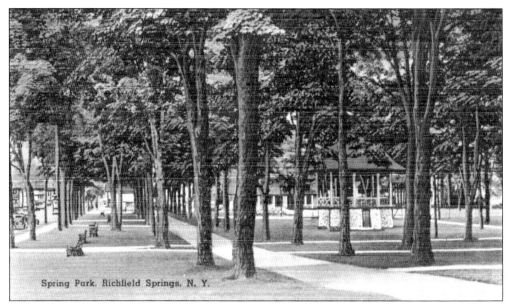

Spring Park, Richfield Springs, N. Y.

SPRING PARK, RICHFIELD SPRINGS, NEW YORK. Spring Park extends eastward from the intersection of Main and Church Streets in the center of Richfield Springs. Established around the original sulphur spring that made this a revered location for the indigenous Indian population, the park was an attractive village square, which for years had provided a place to rest, meet friends, celebrate community events, and enjoy a concert at the 1904 bandstand.

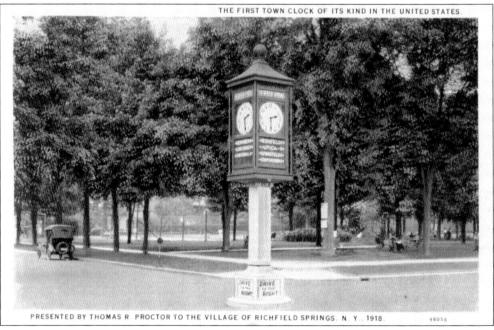

THE FIRST TOWN CLOCK OF ITS KIND IN THE UNITED STATES.

PRESENTED BY THOMAS R PROCTOR TO THE VILLAGE OF RICHFIELD SPRINGS. N. Y., 1918.

TOWN CLOCK, RICHFIELD SPRINGS, NEW YORK. Thomas Proctor owned the Spring Park Hotel in Richfield Springs. Although a native of Utica, he had great affection for Richfield Springs, and to show his appreciation, he donated this clock to the town. It is said to be the first of its kind in the United States. For several years, the clock stood in the intersection of Main and Church Streets, but later it was moved to Spring Park.

56

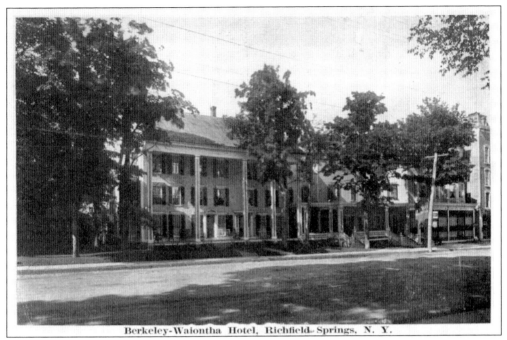

Berkeley-Waiontha Hotel, Richfield Springs, N. Y.

BERKELEY-WAIONTHA HOTEL, RICHFIELD SPRINGS, NEW YORK. This deluxe hotel was described as "a delightful colonial house with spacious halls and large, comfortable rooms." In the 1920s, William T. Johnson, proprietor of the hotel, led the charge for the formation of the Automobile Club of Richfield Springs and was elected the organization's first president. The club's purpose was to aid the good roads movement and facilitate the spread of touring information.

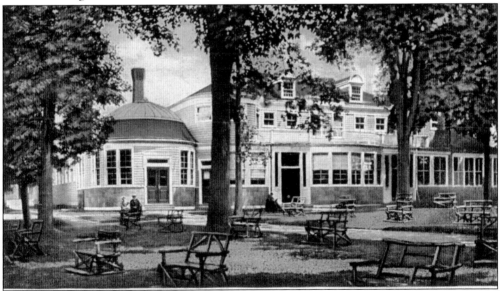

BATH HOUSE, RICHFIELD SPRINGS, NEW YORK. Guests at the Bath House were in the lap of luxury. The rotunda contained bazaars, manicure rooms, doctors' offices, the respiration room, the glass dome of the sun bath, and the resting parlors. Extending from the front were a ladies' wing, a men's wing, and a center wing containing more luxurious private baths, the massage rooms, the Turkish baths, and the swimming pool.

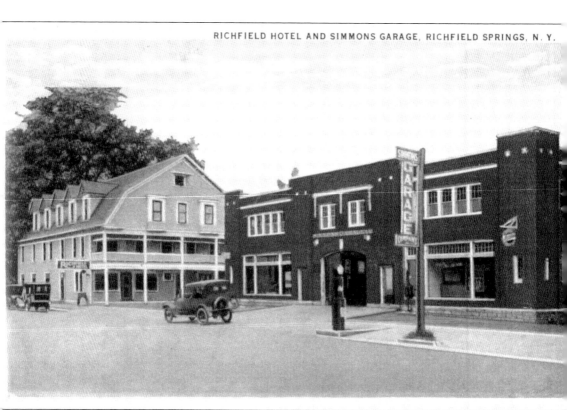

RICHFIELD HOTEL AND SIMMONS GARAGE, RICHFIELD SPRINGS, NEW YORK. Simmons Garage was remarkably advanced for the 1920s when this card was produced. The freestanding building was well-marked with an attractive sign, and the large windows provided excellent views of the new car showrooms within. Access to the garage area was directly from Main Street through the arched doorway in the center of the building. The single gasoline pump at the curb is the only accession to the early automobile era. The adjacent Richfield Hotel had a uniquely homey appearance with its Gambrel roof and dormers. The covered, two-story porches provided a pleasant view of Main Street. The hotel has been demolished, but the garage building remains. It is included in the West Main Street/St. James Street Historic District, which is on the National Register of Historic Places.

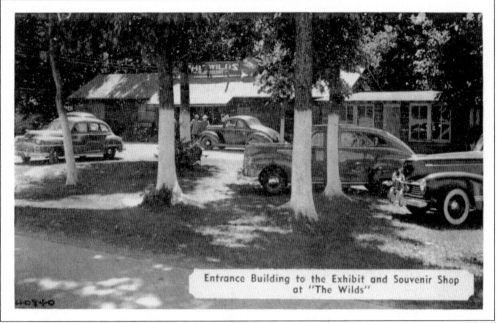

Entrance Building to the Exhibit and Souvenir Shop at "The Wilds"

THE WILDS, WARREN, NEW YORK. The numerous automobiles (above photograph) and visitors (below photograph) confirm that The Wilds was a popular roadside attraction throughout the early years of Route 20. The caption on the back of the card above reads, "Through this building one enters the Geological Exhibit of Petrified Creatures that lived 285 millions years ago, shown in their natural habitat." The card below shows an excavation in progress. Other cards from the same era inform visitors that 90 percent of the creatures shown were found on the premises and were first discovered in 1934. The Wilds contained a museum, a trail of dinosaur statues, and a fossil shop. Children especially enjoyed the pit in the back where they could dig for fossils and keep any that they found.

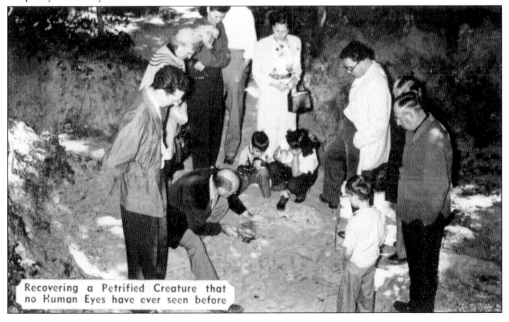

Recovering a Petrified Creature that no Human Eyes have ever seen before

59

DAR Chapter House, West Winfield, New York. The West Winfield Chapter of the Daughters of the American Revolution was organized in 1919 and named in honor of Gen. Winfield Scott. This picturesque colonial house, located in West Winfield Memorial Park, was donated to the chapter in 1921 by Lynn B. Wheeler. The house was noted for its antique furnishings and museum pieces.

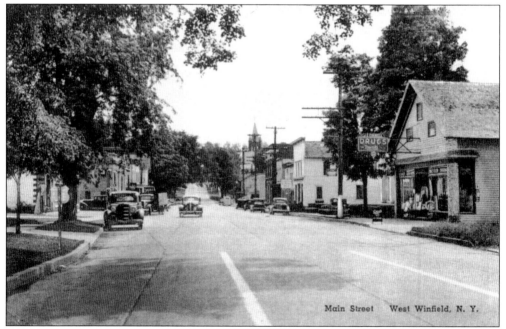

Main Street West Winfield, N. Y.

Main Street, West Winfield, New York. The sender of this card was impressed with this area of New York. She told her friend in Ohio, "This is beautiful country and a lovely village." She did not indicate if she was staying in West Winfield or just passing through.

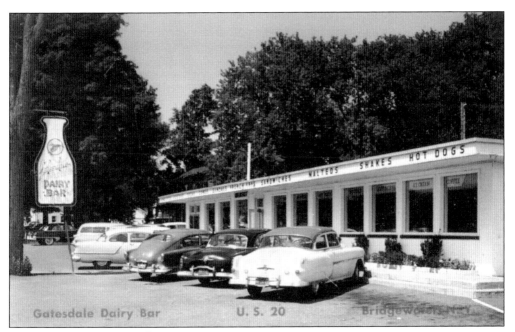

Gatesdale Dairy Bar　　　U. S. 20　　　Bridgewater, N.Y.

GATESDALE DAIRY BAR, BRIDGEWATER, NEW YORK. This business was founded in 1941, but the building shown in this postcard was constructed in 1951. It was described on the back as the "Largest, most modern Dairy Bar in central New York—a good place to stop between Syracuse and Albany." A large old-style milk bottle suspended from a tree made the location easy to find.

BRIDGEWATER AUTO MUSEUM, BRIDGEWATER, NEW YORK. During its 40-year existence, this museum promoted the romance of the automobile through its display of antique "Horseless Carriages" in gas, steam, and electricity. The cars were retained in their original appearance, and many were in good running order. This card shows one of the museum's prized possessions, a very early Oldsmobile.

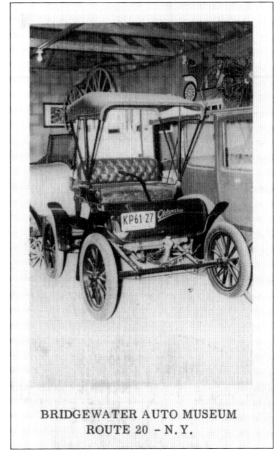

BRIDGEWATER AUTO MUSEUM
ROUTE 20 - N.Y.

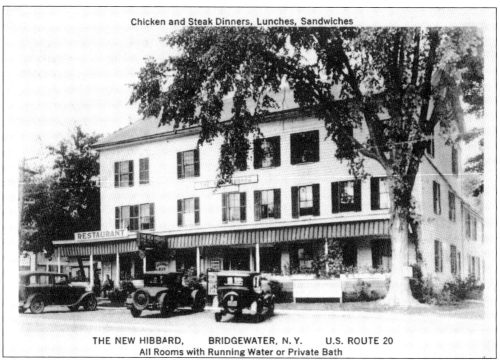

THE NEW HIBBARD, BRIDGEWATER, NEW YORK. Originally a stagecoach stop dating to the mid-1800s, the New Hibbard appears to have retained its popularity over the years. Steak and chicken dinners, together with draught beer, were featured in the hotel's dining room and on the large, shaded front porch. The cars parked in front of the hotel are from the late 1920s–early 1930s.

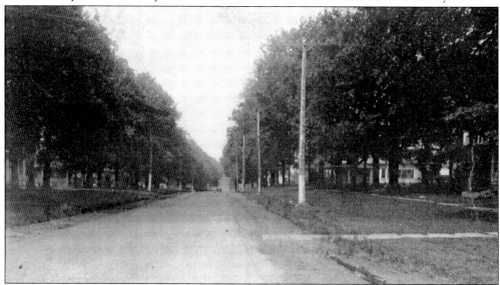

MAIN STREET, MADISON, NEW YORK. Route 20 followed this pleasant residential street through the small community of Madison, New York. This card was mailed in 1936, and the sender reported that they had driven for nine hours and covered over 350 miles, and the car was running very well. Neither the origin nor destination of their trip was mentioned, but they were averaging 40 miles per hour, a respectable speed for the time.

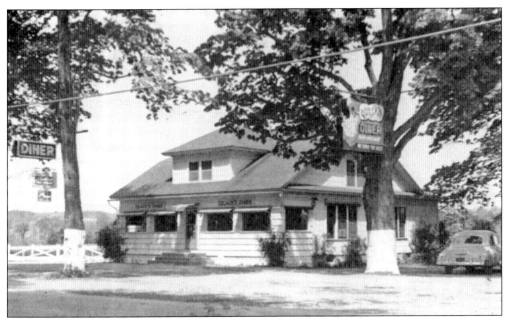

QUACK'S DINER, MADISON, NEW YORK. Quack's Diner is a landmark roadside restaurant with a unique name. This view, made soon after the diner was established in 1947, shows a small house that had been converted into the restaurant. Signs were suspended from tree branches in front of the building. The diner's slogan was "Going east or west, we serve the best."

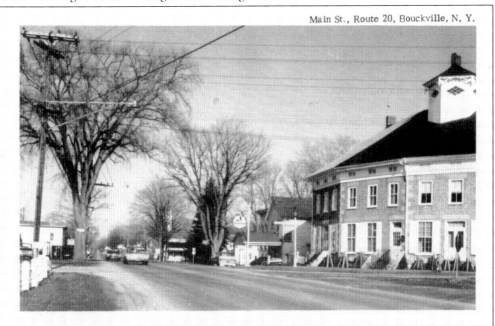

MAIN STREET AND COOLIDGE BUILDING, BOUCKVILLE, NEW YORK. The unusual building on the right was constructed between 1850 and 1851 by James Coolidge. The six-sided cupola is said to represent Coolidge's five wives, and intended sixth, who died before their wedding. Throughout the years, it has accommodated many businesses, including grocery, hardware, dry goods, and antique stores. The building is on the National Register of Historic Places.

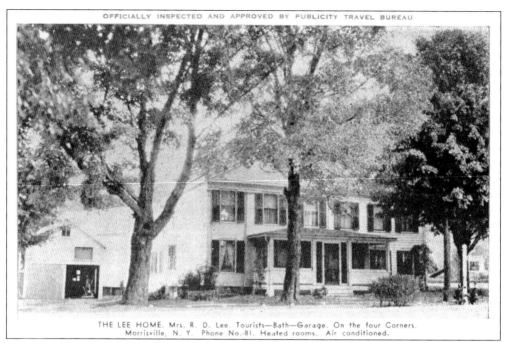

THE LEE HOME. Mrs. R. D. Lee. Tourists—Bath—Garage. On the four Corners.
Morrisville, N. Y. Phone No.-81. Heated rooms. Air conditioned.

THE LEE HOME, MORRISVILLE, NEW YORK. Typical of many rural communities in which a geographic site was more widely recognized than a street address, this 1930s tourist home simply used "On the Four Corners" to direct clients to its location at the town's main intersection. This site is now the village park.

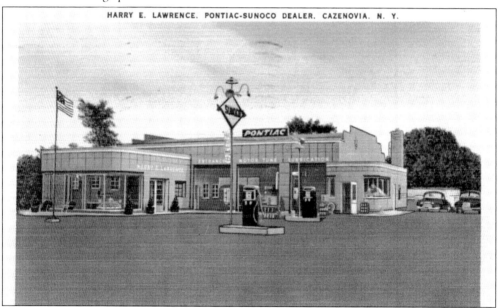

HARRY E. LAWRENCE. PONTIAC-SUNOCO DEALER. CAZENOVIA. N. Y.

HARRY E. LAWRENCE, CAZENOVIA, NEW YORK. The caption on this card paints a colorful picture. It states, "This modern service station is located on U.S. Route 20, on the shores of Cazenovia Lake. Built on an historic site; a place where earliest East-West roads, then railroads appeared; only 150 years since Indian ponies trod these trails." The card was written while the sender was having her oil changed.

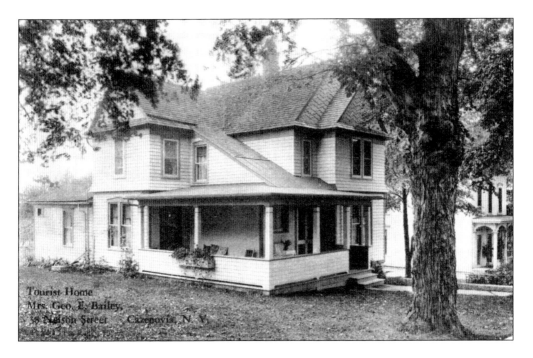

BAILEY TOURIST HOME AND "CRESTMONT" TOURIST HOME, CAZENOVIA, NEW YORK. The two 1930s tourists homes on this page were next-door neighbors at 46 and 42 Nelson Street respectively, on the east side of Cazenovia. The home featured on the card below can also be seen at the right of the card above. One can only hope that the proprietors, Mrs. Bailey and Mrs. Munger, were friends as well as competitors, although Mrs. Munger may have attempted to one-up her neighbor by giving her home the fancy name "Crestmont."

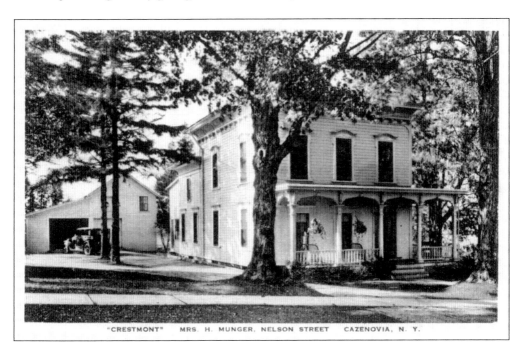

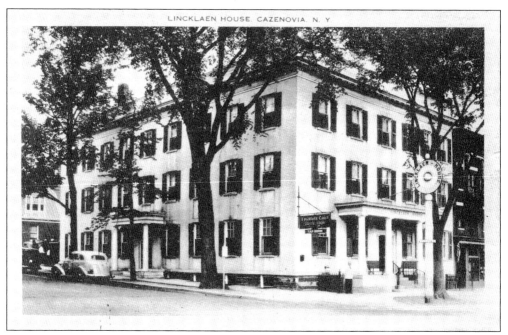

LINCKLAEN HOUSE, CAZENOVIA, NEW YORK. Opened in 1836, this hotel was among the most famous along Route 20. It attracted important visitors from New York, Washington, D.C., Philadelphia, and elsewhere throughout the east. Pres. Grover Cleveland and John D. Rockefeller were guests, as were famous actors and comedians who appeared at the surrounding theaters. The sender of this postcard described the Lincklaen House as "fiendishly expensive—but good."

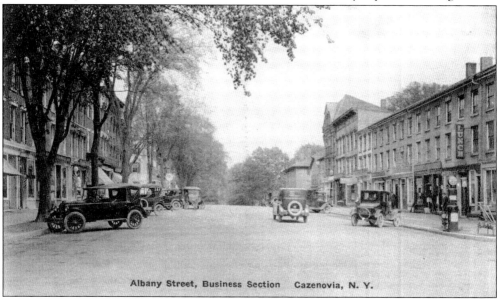

Albany Street, Business Section Cazenovia, N. Y.

BUSINESS SECTION, CAZENOVIA, NEW YORK. Route 20 followed Albany Street through Cazenovia. This view shows the attractive business district with many automobiles parked at the curbs. Local citizens and tourists could service their cars at the curbside gas pumps or have lunch at the restaurant on the right side of the street. Cazenovia's business section was adorned with large shade trees when this photograph was taken in the 1920s.

THE GOLDEN RESTAURANT, CAZENOVIA, NEW YORK. The description on the back of this card says, "Our 21st Year—Home American Cooking." The card was postmarked in 1939, indicating that the restaurant had been in business throughout the entire existence of Route 20. The description goes on to say, "We lead the rest and serve the best—to people going east or west."

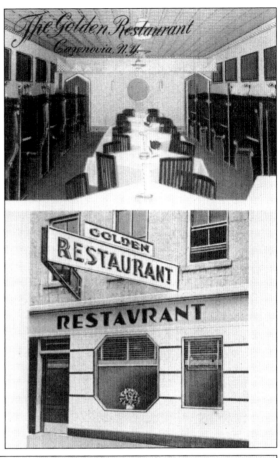

THE COFFEE SHOP, CAZENOVIA, NEW YORK, Located at 84 Albany Street, the Coffee Shop was another of Cazenovia's Main Street restaurants dating to the 1930s. No doubt the local populace, as well as travelers passing through the city on Route 20, took advantage of the "Pleasant Dining" offered at this restaurant.

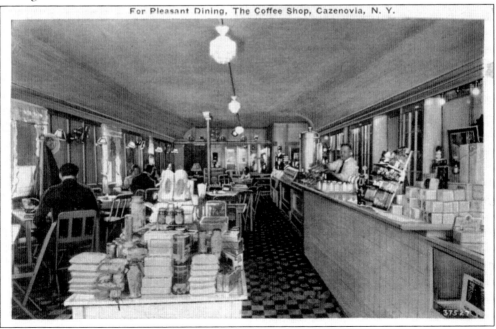

For Pleasant Dining, The Coffee Shop, Cazenovia, N. Y.

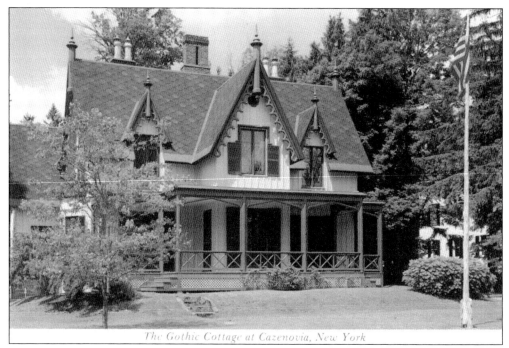

The Gothic Cottage at Cazenovia, New York

GOTHIC COTTAGE, CAZENOVIA, NEW YORK. This beautiful Greek Revival cottage was built in 1847 by Jacob Ten Eyck and for much of its existence was a private residence. In 1965, plans were being made to demolish it in favor of a parking lot. Fortunately, a determined effort by local citizens resulted in the cottage being purchased and renovated by the town, where it then served as the Cazenovia Town Hall.

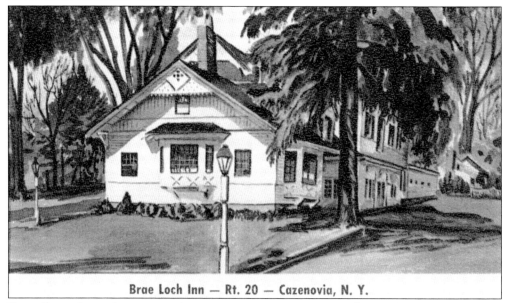

Brae Loch Inn — Rt. 20 — Cazenovia, N. Y.

BRAE LOCH INN, CAZENOVIA, NEW YORK. Four generations of central New Yorkers have cherished the Brae Loch Inn as the place to celebrate special times in their lives. The Brae Loch Inn (which means Hill Lake View) proclaimed itself to be "as close to a Scottish Inn as you will find this far west of Edinburgh!" It has been in operation since 1946.

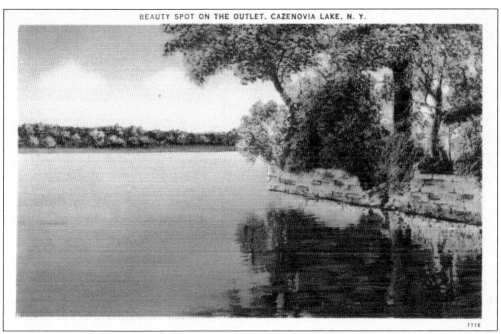

BEAUTY SPOT AT THE OUTLET, CAZENOVIA LAKE, NEW YORK. Lakeland Park, the site of this peaceful scene, was located at the western end of Albany Street in Cazenovia. Here Route 20 turned south, passed over Chittenango Creek shown at the right of the picture, and followed the shore of Cazenovia Lake as it left the city.

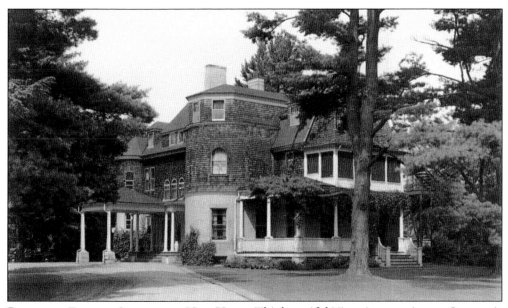

BREWSTER ESTATE, CAZENOVIA, NEW YORK. This beautiful Victorian mansion on Cazenovia Lake has occupied a prominent location on Route 20 since 1891. The estate was the summer home of Benjamin Brewster, a partner of John D. Rockefeller in Standard Oil. Brewster was a financial genius who also was a leader in the development of New York City's elevated railroad system and other early railroads throughout the country.

69

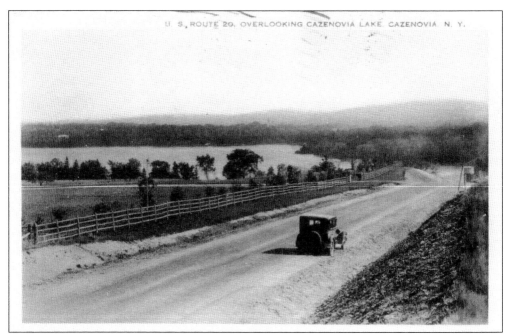

SCENES ON ROUTE 20, CAZENOVIA, NEW YORK. The two cards on this page illustrate the evolution of highway construction techniques in the 1920-1930s. The roadbed in the photograph above is still gravel, but the surface had been elevated and ditches created to provide better drainage and easier snow removal. The photograph below shows that the road no longer followed the natural terrain over the tops of the hills and though valleys. Rather, the topography was remodeled to accommodate the roadway. In this instance a considerable amount of earth and rock had been removed to provide a more favorable grade level. Wider ditches were incorporated into the design to accommodate runoff from rain and snow and the road was paved. Three cars from the early 1930s were taking full advantage of this modern stretch of highway.

SCENE ON ROUTE 20 NEAR CAZENOVIA, N. Y.

Five

THE FINGER LAKES

The Finger Lakes in west-central New York have long been recognized among the beauty spots of the eastern United States. Countless visitors have been drawn to the natural attractions of the area. Until the development of the Interstate Highway System in the 1950s, most visitors arriving by automobile did so on Route 20, the main east-west highway through the area. Even today it is the most convenient link between the lakes.

The 11 Finger Lakes are contained within five counties, Onondaga, Cayuga, Seneca, Ontario, and Livingston. Seven lakes, Otisco, Skaneateles, Owasco, Cayuga, Seneca, Keuka, and Canandaigua Lakes, are termed major. Four lakes farthest west, Heneoye, Canadice, Hemlock, and Conesus, are smaller and are considered minor. Cazenovia Lake, farther to the east, is sometimes included, adding a 12th lake to the list.

The unique shapes of the lakes gave rise to the name of the region. All are long and narrow, Cayuga and Seneca being the longest at close to 40 miles. None of the lakes is more than 3.5 miles wide. The lakes parallel each other in a north-south direction, and from the air their shape and relationship resemble the fingers of a hand.

The Finger Lakes are extremely deep, Seneca being the deepest (618 feet) followed by Cayuga (435 feet). The size and depth provide a volume of water sufficient enough to produce a moderating "lake effect" on the temperature of the surrounding countryside. Crops are protected from temperature extremes, especially late frosts in the spring and early frosts in the fall. This phenomenon was found to be favorable for grape production. Several vineyards established along Route 20 early in the 20th century add to the attractiveness of the highway.

Colorful, historic communities line Route 20 in the Finger Lakes region, some being home to hotels and inns that date to the 18th century. Seasonal visitors have taken advantage of the lakes, and the permanent residents have made historic contributions to the extent that they are honored by monuments and parks. Many buildings are listed on the National Register of Historic Places and have been tourist attractions for decades.

SCENIC VIEWS BETWEEN CAZENOVIA AND SKANEATELES, NEW YORK. The 30-mile section through which Route 20 passed west of Cazenovia was especially attractive with picturesque valleys and wooded hillsides. Known locally as Pompey Hollow, the vistas along this stretch of the highway inspired a series of unique linen postcards during the 1930s, two of which are shown on this page. Artistic renderings of the highways, fields, and hills are shown in both the above and below views. Stylized drawings of contemporary automobiles conveyed the growing popularity of motor travel and were intended to promote even greater use of the highway. Note the Route 20 sign at left in the above picture.

SCENIC BEAUTY, POMPEY HOLLOW, ROUTE 20, CAZENOVIA, N. Y.

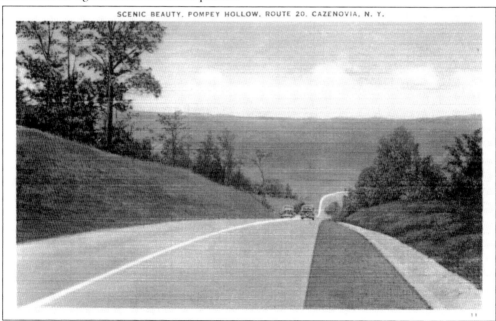

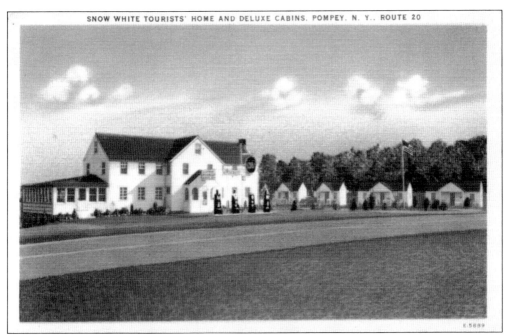

SNOW WHITE TOURIST HOME AND CABINS, POMPEY, NEW YORK. The original large farmhouse on this site underwent a transformation into a thriving roadside business catering to motorists on Route 20. Those wanting only gas could be served at the filling station in the front. Hungry travelers could eat in the restaurant built onto the side of the house, and "deluxe" cabins of various sizes were available for overnight guests.

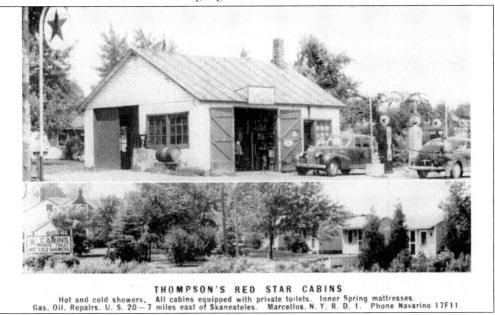

THOMPSON'S RED STAR CABINS
Hot and cold showers. All cabins equipped with private toilets. Inner Spring mattresses.
Gas, Oil, Repairs. U. S. 20—7 miles east of Skaneateles. Marcellus, N. Y. R. D. 1. Phone Navarino 17F11.

THOMPSON'S RED STAR CABINS, MARCELLUS, NEW YORK. Marcellus is a crossroads community on Route 20, but the owners of this cabin camp took advantage of the greater prominence and popularity of neighboring Skaneateles in their advertising. Travelers could have their cars serviced while they rested well on inner spring mattresses in cabins equipped with private toilets.

73

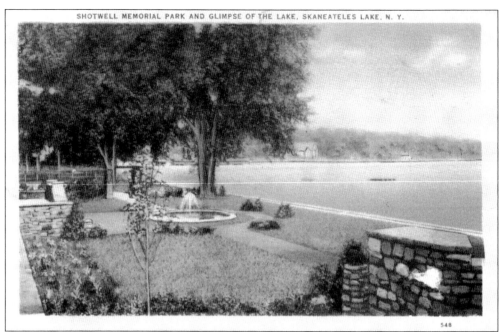

SHOTWELL MEMORIAL PARK, SKANEATELES, NEW YORK. Shotwell Park, "one of the most beautiful War Memorials in the country," extended from Genesee Street (Route 20) to Skaneateles Lake. The park was planned to memorialize World War I veterans, as later wars were not envisioned. Subsequently, the park was rededicated to honor veterans of World War II and the Korean and Vietnam Wars. Future plaques will memorialize persons who served in Granada, Lebanon, Panama, and the Persian Gulf.

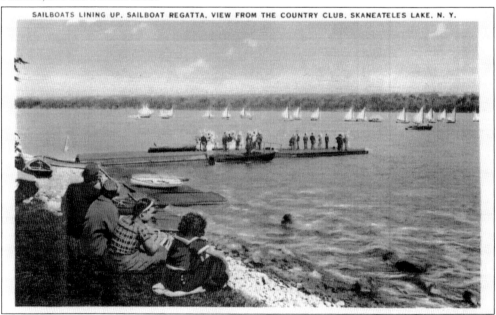

SAILBOAT REGATTA, SKANEATELES, NEW YORK. Sailboat racing was a popular Skaneateles Lake activity for participants and viewers alike. Most summer weekends found the lakeshore crowded with locals and vacationers watching the races or simply enjoying the beautiful setting.

KAN-YA-TO INN, SKANEATELES, NEW YORK. Isaac Sherwood built the Sherwood Tavern in 1807 to house the headquarters of his expanding stagecoach business and to provide accommodations for his customers and the traveling public. His foresight was perfect and under his management, and that of a succession of owners, the hotel has been in business for more than 200 years. New owners in 1923 christened the hotel the Kan-Ya-To Inn (above photograph), and it operated under this name during the early years of Route 20. The location was advertised by the uniquely designed postcard below, showing that all roads led to their inn. Following World War II, the name of this venerable hotel had come full circle. Kan-Ya-To was retired in favor of the name of the original tavern of more than 200 years earlier.

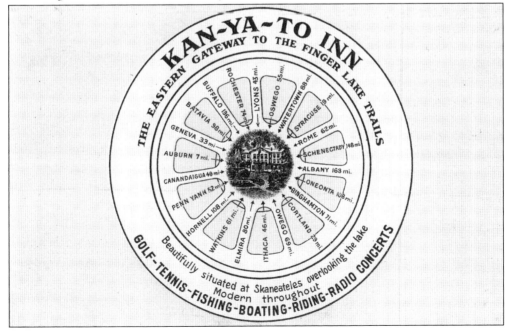

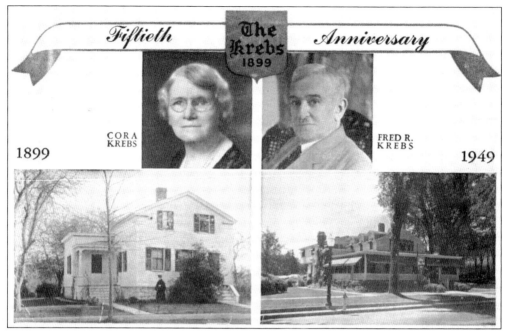

THE KREBS, SKANEATELES, NEW YORK. In the summer of 1899, Fred and Cora Krebs started serving meals to their neighbors; board was $8 per week with three meals a day. The restaurant has been in operation ever since. In 1946, the upstairs, where the Krebs had their living quarters, was converted into a cocktail lounge and sitting rooms. The multi-view card above celebrated the golden anniversary of Krebs restaurant. The card below, also multi-view, illustrates the expansion that had taken place during the ensuing 50 years and the attractive gardens surrounding the restaurant. The sender of the card told her friend that the food here was out of this world and that she was having a nice trip, which was doing her good.

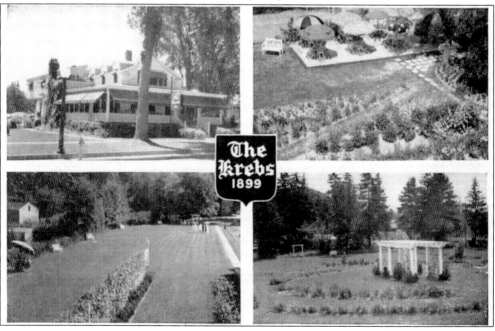

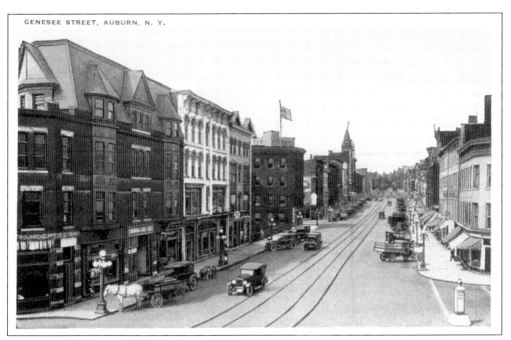

GENESEE STREET, AUBURN, NEW YORK. Route 20 passed through Auburn on Genesee Street, shown here in the 1920s. The tracks indicate that trolleys were still in use, but many citizens were turning to the automobile as their primary means of transportation. At least one person still relied on his horse, and another chose a motorcycle with a sidecar.

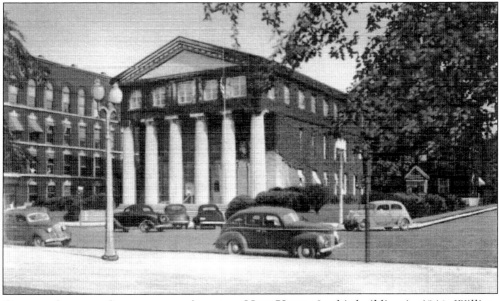

CAYUGA COUNTY COURTHOUSE, AUBURN, NEW YORK. In this building in 1846, William Seward, future secretary of state in Abraham Lincoln's administration, defended William Freeman, a black man accused of murdering four members of a New York family. Seward set legal precedent by arguing for insanity rather than criminal intent. Although his defense was unsuccessful, recognition of mental illness as a legitimate plea was a significant advance in 19th-century jurisprudence.

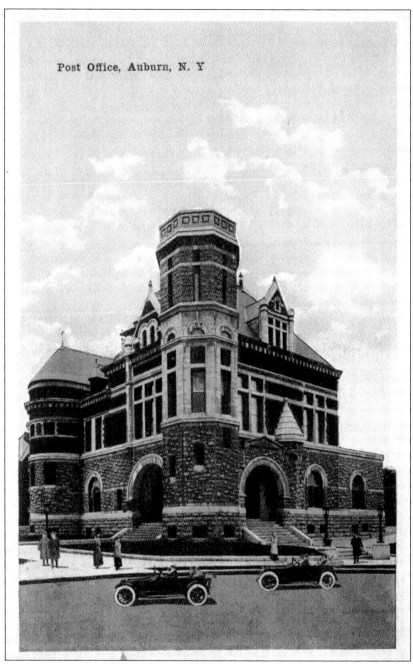

Post Office, Auburn, N. Y

U.S. Post Office, Auburn, New York. According to some sources, the size and ornateness of early post offices was a function of the size of the community, the amount of business it was projected to generate, and the power of the Congressional delegation that represented the area. As Auburn was a relatively small town when this post office was built, it might be assumed that the representative and senators exerted considerable influence as the building is an architectural masterpiece that is far more elaborate than post offices in comparably sized cities. This post office has served the community for more than a century and is listed on the National Register of Historic Places.

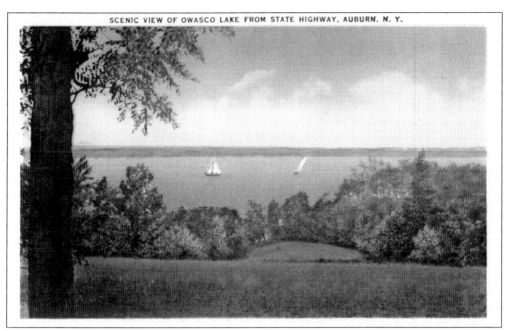

SCENIC VIEW OF OWASCO LAKE FROM STATE HIGHWAY, AUBURN, N. Y.

OWASCO LAKE, AUBURN, NEW YORK. Lake Owasco was one of the Finger Lakes not directly adjacent to Route 20, although its location approximately 2 miles south of the highway did not deter visits to its beautiful shoreline. Scenes such as this were characteristic of all of the Finger Lakes.

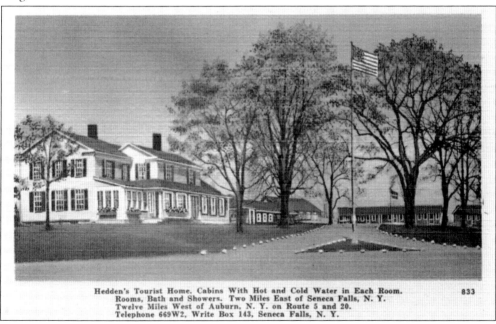

Hedden's Tourist Home. Cabins With Hot and Cold Water in Each Room.
Rooms, Bath and Showers. Two Miles East of Seneca Falls, N. Y.
Twelve Miles West of Auburn, N. Y. on Route 5 and 20.
Telephone 669W2, Write Box 143, Seneca Falls, N. Y. 833

HEDDEN'S TOURIST HOME, SENECA FALLS, NEW YORK. The success of this tourist home, and its transition from guest house to motel, is evident on the card. The establishment had been expanded by the addition of several small units, which were referred to as cabins, although they had an early motel design. The amenities in the main house and the cabins included hot and cold water and baths in each room.

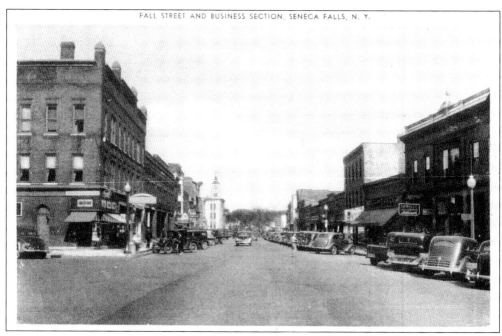

FALL STREET, SENECA FALLS, NEW YORK. In 1848, five women led by Elizabeth Cady Stanton hosted the country's First Women's Rights Convention in Seneca Falls. Approximately 300 people attended. A resolution was unanimously adopted for "overthrowing the monopoly of the pulpit, and securing to women equal participation in the various trades, professions and commerce." The site of the convention is a National Historical Park on Fall Street.

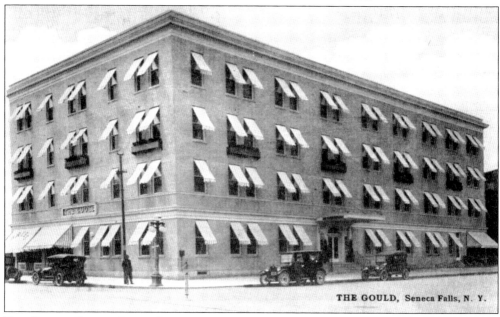

THE GOULD, Seneca Falls, N. Y.

THE GOULD, SENECA FALLS, NEW YORK. An early advertisement for this hotel reads as follows: "European Plan—All rooms with hot and cold water. Single rooms. Rooms with bath and suites. One mile from beautiful Cayuga Lake. Boating, Canoeing, Swimming. Rates $1.50 up. In the heart of the Finger Lakes on the State Highway."

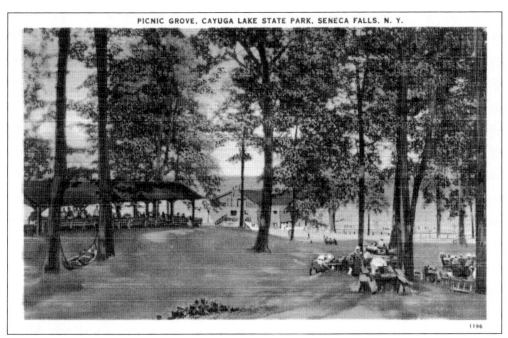

PICNIC GROVE, CAYUGA LAKE STATE PARK, SENECA FALLS, N. Y.

1196

PICNIC GROVE, SENECA FALLS, NEW YORK. The reason for the popularity of the Finger Lakes is evident in this 1930s postcard. The picnic ground on Seneca Lake was an ideal spot for local citizens, as well as travelers on Route 20, to relax, swim at the beach, and simply enjoy the beautiful lake.

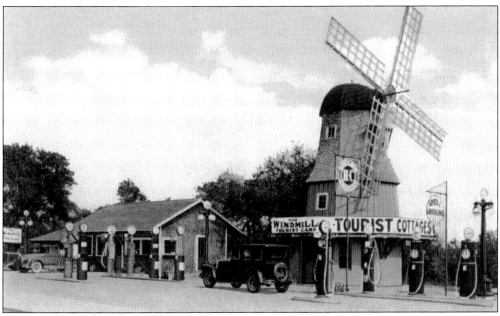

WINDMILL TOURIST CAMP, SENECA FALLS, NEW YORK. The authentic Dutch windmill attracted motorists to this 1920s tourist camp, consisting of 14 furnished cabins, tea room, and gift shop. Cabins rented for $1 a night. Water for toilets and showers, located in the windmill, was pumped from the local river using a converted Model T Ford as the source of power. Ten gas pumps served the needs of motorists.

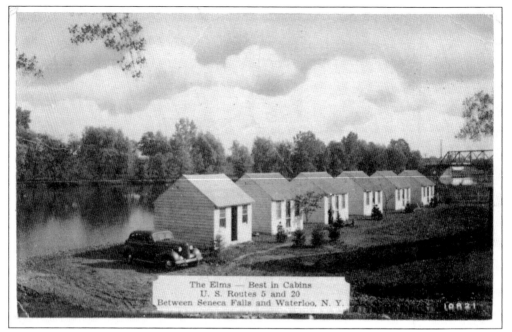

The Elms — Best In Cabins
U. S. Routes 5 and 20
Between Seneca Falls and Waterloo, N. Y.

THE ELMS. Travelers who carried fishing poles in their cars had ample opportunity to pursue their sport while staying at this cabin camp on the banks of the Seneca River. They could fish from the riverbank behind their cabin, or drop a line from the Route 20 bridge in the distance. The automobile indicates that this photograph was made in the 1930s.

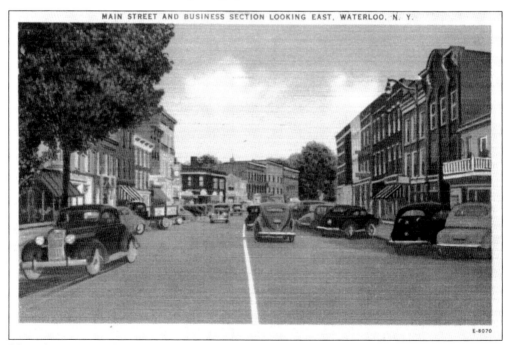

MAIN STREET AND BUSINESS SECTION LOOKING EAST, WATERLOO, N. Y.

MAIN STREET AND BUSINESS SECTION, WATERLOO, NEW YORK. This 1940s view of Waterloo shows an attractive and busy commercial district. The Waterloo Pharmacy and the State Theater featured in the following photograph can be seen on the left in the distance.

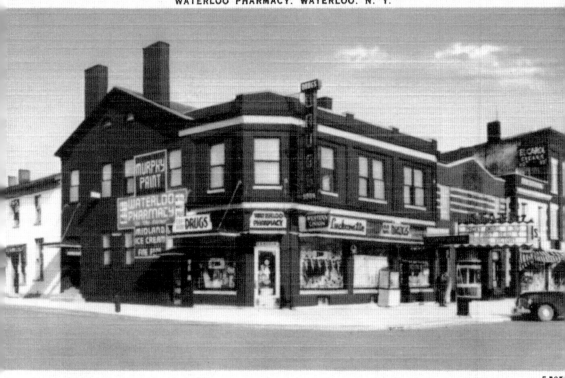

E-595

WATERLOO PHARMACY, WATERLOO, NEW YORK. One can imagine Mickey Rooney and Judy Garland sipping lemon phosphates at this drugstore's soda fountain. The State Theater next door was showing a double feature, although neither was an Andy Hardy film. The first movie was *Her First Beau*, and the second was *Shining Victory*. Both were released in 1941. Much earlier, in 1865, Waterloo druggist Henry Welles proposed decorating the graves of fallen soldiers. Other communities joined in on the established date of May 30. In May 1966, the U.S. House of Representatives and Senate unanimously passed Concurrent Resolution 587, which stated, "Resolved, that the Congress of the United States, in recognition of the patriotic tradition set in motion one hundred years ago in the Village of Waterloo, New York, does hereby officially recognize Waterloo as the birthplace of Memorial Day."

THE SCYTHE TREE FARM, WATERLOO, NEW YORK. James Johnson joined the Union army in October 1861. He hung his scythe in the crotch of a tree and asked that it be left there until he returned. Tragically, he was killed in May 1864. The scythe was never removed, and for many years, his valor was commemorated by placing a flag on his scythe blade. At the onset of World War I, two brothers, Raymond and Lynn Schaffer, who were then living on the farm, joined the U.S. Army and U.S. Navy respectively. They, too, placed a scythe in the tree next to that of Sergeant Johnson. Flags were placed on the three scythe blades until the end of the war. Fortunately, both Schaffer boys returned safely. The handles of the scythes were removed but all three blades remained in the tree.

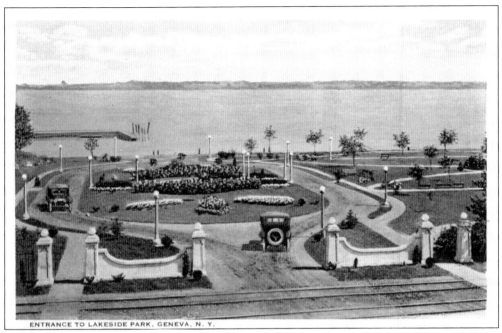

ENTRANCE TO LAKESIDE PARK, GENEVA, N. Y.

LAKESIDE PARK, GENEVA, NEW YORK. Route 20 followed the north shore of Seneca Lake in Geneva. Travelers might have found this attractive park between the road and the lake to be a pleasant place to take a break from their drive.

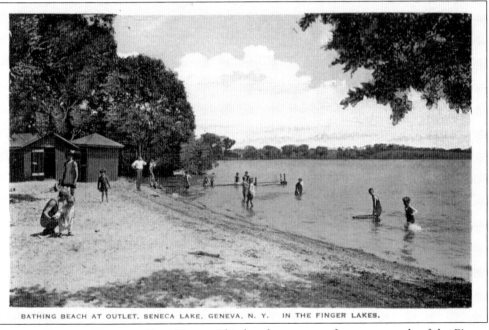

BATHING BEACH AT OUTLET, SENECA LAKE, GENEVA, N. Y. IN THE FINGER LAKES.

BATHING BEACH, GENEVA, NEW YORK. This beach was one of many on each of the Finger Lakes that visitors could enjoy. Swimming, sailing, fishing, and other water sports were popular summertime activities, and ice skating, ice boating, and cross-country skiing were popular in the winter. The spring and autumn colors of the surrounding countryside drew visitors in those seasons.

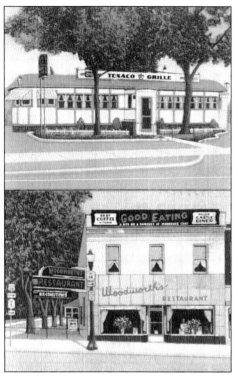

TEXACO GRILL AND WOODWORTH'S RESTAURANT, GENEVA, NEW YORK. This classic diner (left, above) advertised that for over 15 years of 24-hour service, it had provided its customers the best of food and plenty of parking. Although the name and red Texaco Star trademark are shown, there is no other indication on the card that the diner was affiliated with a service station. The shields on the posts in front of Woodworth's corner restaurant (left, below) show that it had a favorable location on Routes 5 and 20 and New York Route 14. The restaurant offered "A Bite or a Banquet at Moderate Cost" and the best coffee in town.

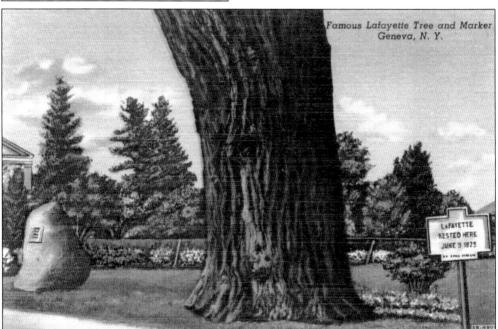

LAFAYETTE TREE, GENEVA, NEW YORK. The Marquis de Lafayette was a young French aristocrat who joined the American Revolution to help the colonies and gain military fame for himself. He succeeded in both. Lafayette fought with George Washington, earning the rank of major general and becoming one of the most admired figures in the War of Independence. In June 1825, Lafayette visited Geneva and is reputed to have rested under this tree.

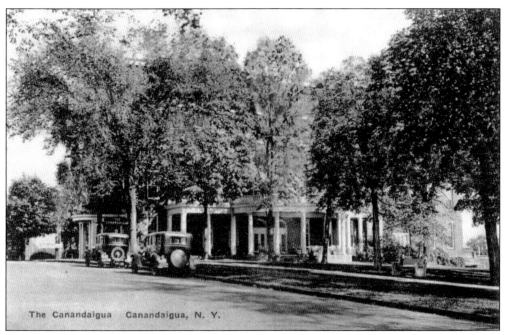

The Canandaigua Canandaigua, N. Y.

THE CANANDAIGUA, CANANDAIGUA, NEW YORK. A 1920s advertisement described the Canandaigua as "An ideal stop for the tourist in the Finger Lakes Region." Located on the main Albany–Buffalo Highway (Route 20), it proclaimed itself to be the finest equipped country hotel in western New York. The restaurants offered excellent cuisine on the European plan.

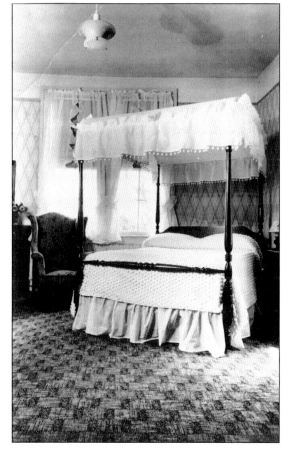

GUEST ROOM, THE CANANDAIGUA, CANANDAIGUA, NEW YORK. The Canandaigua offered tourists both single and en suite rooms at rates of $2 and up. The comfortable guest rooms, appointed with four-poster beds, overstuffed side chairs, and plush carpeting ensured a pleasant and relaxing experience. Private bathrooms were not included in the description.

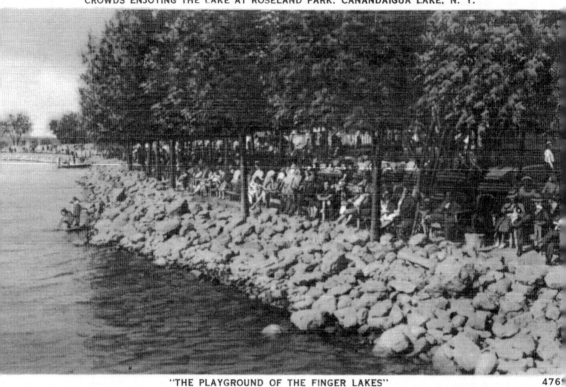

"THE PLAYGROUND OF THE FINGER LAKES" 476

ROSELAND PARK, CANANDAIGUA LAKE, NEW YORK. Roseland Amusement Park, one of the Finger Lakes premier roadside attractions, was located on the north shore of Canandaigua Lake. It held the unique distinction of being one of the first amusement parks in the country that was not served by scheduled public transportation. Its foresightful developers recognized that automobiles were the wave of the future and located this park directly on Route 20, the major highway of the day. Roseland Park started operation in 1925 and continued for 60 years until it closed on Labor Day, September 2, 1985. Throughout the years, many rides and amusements were featured, including the carousel, Ferris wheel, bumper cars, a spook house, and the park's famous wooden roller coaster, the "Skyliner."

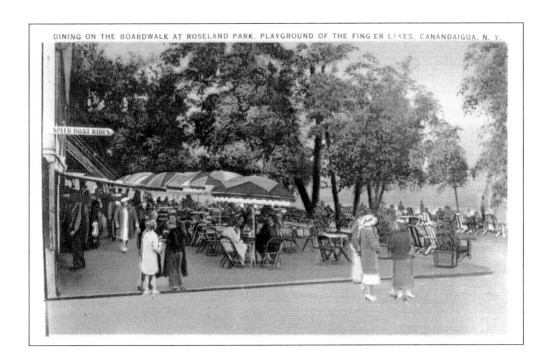

DINING ON THE BOARDWALK AT ROSELAND PARK. PLAYGROUND OF THE FINGER LAKES. CANANDAIGUA. N. Y.

ROSELAND PARK, CANANDAIGUA LAKE, NEW YORK. Roseland Park was popular with all ages. The lake was the main attraction with its beaches, boating, and musical events held along the shore. Children and teenagers enjoyed the rides and others found activities that suited their tastes. The above photograph shows crowds of visitors strolling on the boardwalk through the park's beautifully landscaped grounds while others enjoyed a picnic. Below, park visitors play a game of miniature golf.

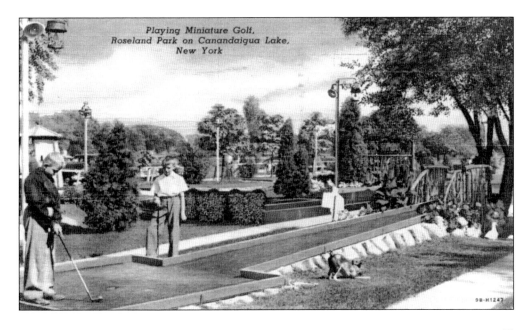

Playing Miniature Golf,
Roseland Park on Canandaigua Lake,
New York

89

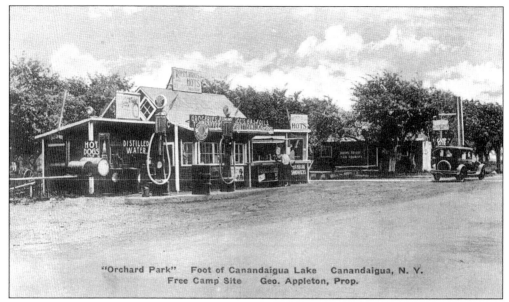

"Orchard Park" Foot of Canandaigua Lake Canandaigua, N. Y.
Free Camp Site Geo. Appleton, Prop.

ORCHARD PARK, CANANDAIGUA, NEW YORK. At this station, a hand-operated lever pumped gasoline into the large glass cylinder, which was marked with lines so the customer could see the amount of gas being purchased. It then flowed by gravity into the car's tank, taking several repetitions to completely fill-up. Hot dogs, hamburgers, coffee, and even buttermilk were available from the lean-to shed at right in the picture.

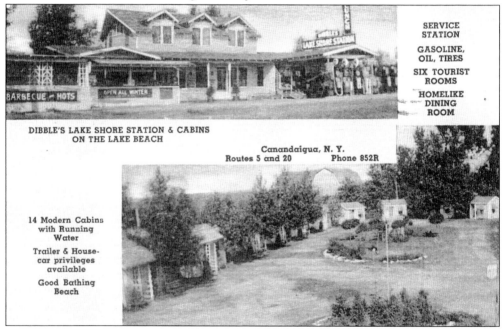

DIBBLE'S LAKE SHORE STATION & CABINS
ON THE LAKE BEACH

SERVICE STATION

GASOLINE, OIL, TIRES

SIX TOURIST ROOMS

HOMELIKE DINING ROOM

Canandaigua, N. Y.
Routes 5 and 20 Phone 852R

14 Modern Cabins with Running Water

Trailer & House-car privileges available

Good Bathing Beach

DIBBLE'S LAKE SHORE STATION AND CABINS, CANANDAIGUA, NEW YORK. Dibble's offered tourist accommodations in the main house or in one of 14 cabins on the attractive grounds. Guests could have their cars serviced at the adjacent station. The writer of this card reported having a nice dinner in the restaurant and then sitting near the lake to hear a band playing by the water.

BIRX MOTOR COURT, CANANDAIGUA, NEW YORK. In contrast to most 1930s–1940s cabin camps throughout the Finger Lakes region, which emphasized their closeness to the lakes and other attractions, Birx took a different approach. This was a no-frills establishment. Fresh air, beautiful rolling hills away from the crowds, and a the promise of a restful night's sleep may have been attraction enough for many early tourists.

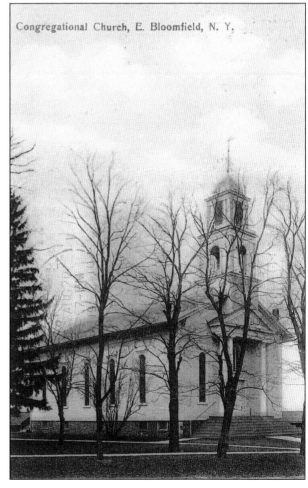

Congregational Church, E. Bloomfield, N. Y.

CONGREGATIONAL CHURCH, EAST BLOOMFIELD, NEW YORK. The church shown on this postcard is one of the most historic in this section of New York. It was founded in 1796. The church is located on the Village Green and is a component of the East Bloomfield Historical District, which is listed on the National Register of Historic Places.

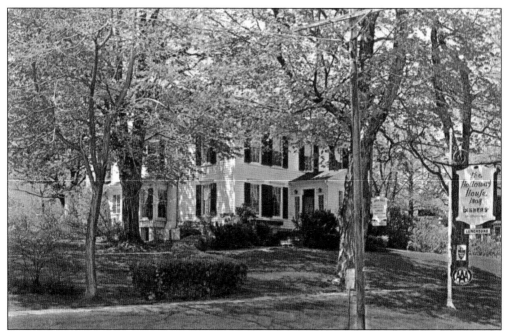

HOLLOWAY HOUSE, EAST BLOOMFIELD, NEW YORK. Like most early roadside inns, a farsighted citizen, village blacksmith Peter Holloway, recognized the need for a tavern to accommodate the westward migration of the population. Unlike most of its contemporaries, the Holloway House has survived. The inn has provided food and shelter with only few interruptions since 1808. The Holloway House is listed on the National Register of Historic Places.

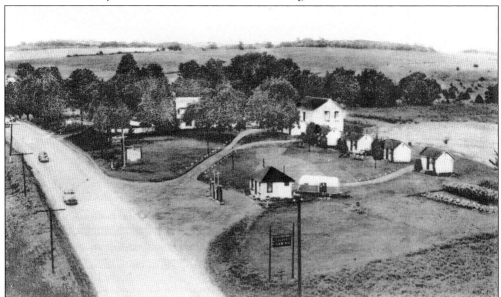

CULVER'S CABINS, EAST BLOOMFIELD, NEW YORK. This low-altitude aerial photograph, taken in the 1930s, shows Culver's to be a small tourist camp and gas station situated among rolling hills of western New York. Every cabin was steam heated and had a private bath. The early Airstream House Trailer parked behind the gas station may have been owned by the management, or possibly had been parked there by an adventurous traveler.

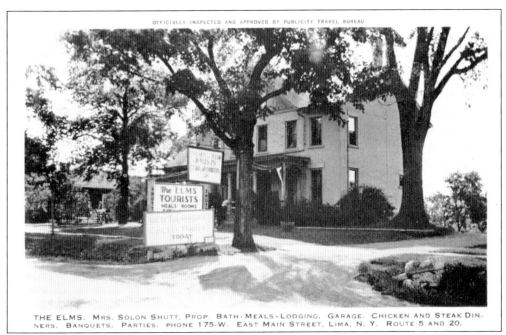

THE ELMS. MRS. SOLON SHUTT, PROP. BATH-MEALS-LODGING. GARAGE. CHICKEN AND STEAK DIN-
NERS. BANQUETS. PARTIES. PHONE 175-W. EAST MAIN STREET, LIMA, N. Y. ROUTE 5 AND 20.

THE ELMS, LIMA, NEW YORK. The proprietor of this 1930s tourist home, Mrs. Solon Shutt, offered complete services—bath, meals, lodging, and garage—to the traveling public. The sign suspended from the tree says, "Chicken and Steak Dinners 75¢ Regular Dinners—50¢." "Old Fashioned Chicken Dinner" was the featured entrée on the day this photograph was taken.

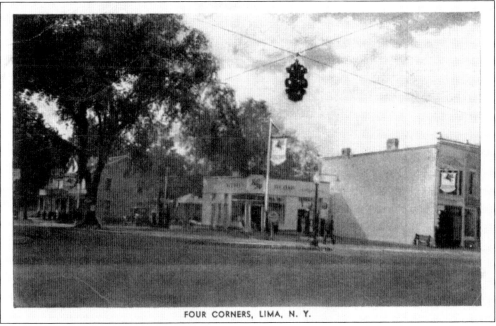

FOUR CORNERS, LIMA, N. Y.

SECONY SERVICE STATION, LIMA, NEW YORK. "Stop at the sign of the Flying Red Horse" was a slogan familiar to early motorists. The Flying Horse, or Winged Pegasus, was the logo trademark of the Socony-Vacuum Oil Company. This station was located at the junction of Main and Rochester Streets, hence the four corners. A Route 20 sign is visible at left in this picture.

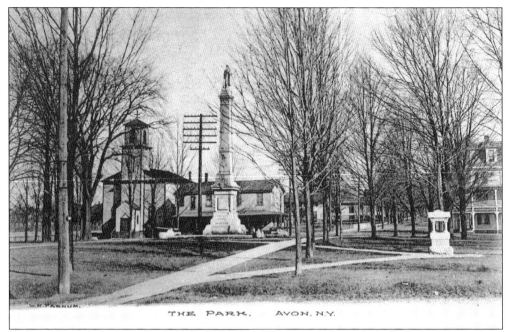

THE PARK. AVON. N.Y.

THE PARK, AVON, NEW YORK. This park, sometimes referred to as Circle Park, is located in the center of Avon. It is bounded by a traffic circle at the junction of Main Street (Route 20) and Genesee Street. The sender of this card in the 1920s invited her friend to "come and see our beautiful park this summer. We always have a celebration on the Fourth."

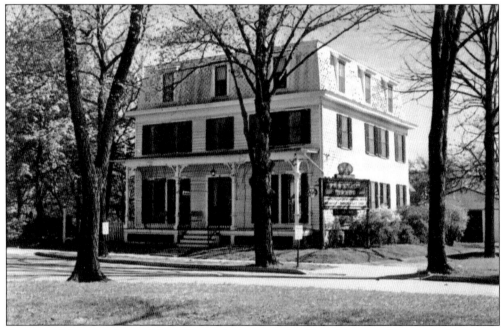

PARKSIDE MANOR, AVON, NEW YORK. As its name implies, this attractive tourist home was located across the street from the park in the beautiful town of Avon. It was open all year, offering modern rooms and baths for overnight guests. Club breakfasts were served daily, and guests could take advantage of the Parkside Manor's gift shop with antique and modern gifts.

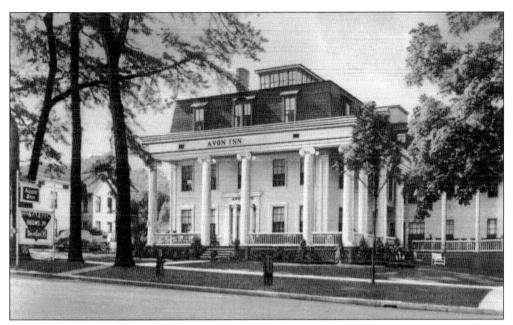

AVON INN, AVON, NEW YORK. The Avon Inn has provided accommodations and fine dining since 1820. Before the Civil War, it was a favorite summer resort for the aristocracy of the Deep South and later for wealthy industrialists and eastern socialites, including George Eastman, Henry Ford, Thomas Edison, Harvey Firestone, and Eleanor Roosevelt. The Avon Inn is listed on the National Register of Historic Places.

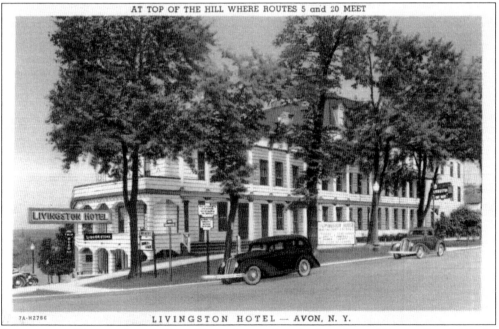

LIVINGSTON HOTEL, AVON, NEW YORK. Located at the junction of Routes 5 and 20, the Livingston Hotel was ideally suited to take advantage of traffic on both highways. Restaurant prices when this photograph was taken in the 1930s included wheat cakes with bacon or sausage for 85¢, hamburgers for 30¢, cheeseburgers for 35¢, and doughnuts for 5¢.

HIGHWAY SCENE NEAR LAKEVILLE, NEW YORK. For approximately the first 10 years of its existence, Route 20 passed through the small village of Lakeville at the northern end of Lake Conesus. The successor road, Alternate Route 20, still goes through the town. Like the other Finger Lakes to the east, the area surrounding Lakeville and Lake Conesus offered motorists strikingly beautiful scenery.

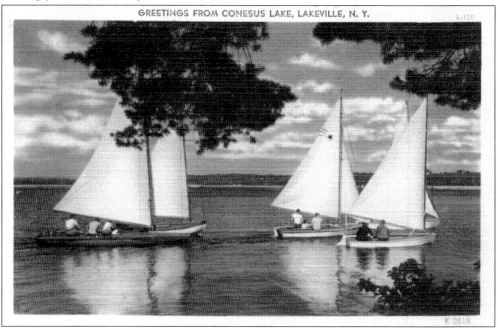

GREETINGS FROM CONESUS LAKE, LAKEVILLE, NEW YORK. Conesus Lake, for years considered the "jewel" of Livingston County, is the westernmost of the 11 Finger Lakes. At approximately 8 miles long and 1 mile wide, it is referred to as a minor lake. Nonetheless, it has always equaled its neighbors in beauty and lake-centered activities during all four seasons of the year.

Six

THE BUFFALO DISTRICT

The Buffalo District occupies the territory from Lakeville on Lake Conesus to the Chautauqua County line southwest of Buffalo. It includes a portion of Livingstone County, and the whole of Wyoming and Erie Counties.

Following original Route 20 through this region can be a challenge due to constant realignments during its early years. As shown on most maps from 1926 through the mid-1930s, upon leaving Canandaigua, Route 20 went west to Avon. There the highway turned south to Lakeville and Lake Conesus and on to Geneseo. From there the road proceeded west to Warsaw and subsequently through several small villages until it reached East Aurora and finally Orchard Park. The illustrations and captions in this chapter follow that route. On modern maps it is designated as US20A or Alternate 20.

It should be noted that from the late 1930s to the present, the course of Route 20 has been directly west from Avon through the towns of Alexander, Darien, Alden, Lancaster, and then to Depew. There the road turns south rejoining present US20A (original Route 20) at Orchard Park. This component of Route 20 is almost as old as the original and it, too, is scenic and historic and well worth a visit.

The Buffalo District contains several significant historical sites. In 1977, Geneseo's entire Main Street was listed on the National Register of Historic Places, and in 1991, Geneseo was declared a National Landmark Village. Twenty miles west, Warsaw also is home to a national historic site. The Monument Circle Historic District encompasses 21 late-19th- and early-20th-century civic, religious, and domestic properties in the historic core of the city. Still further west in East Aurora, the *c.* 1900 Roycroft Society campus and Pres. Millard Fillmore's home are National Historic Register sites.

Buffalo illustrates Route 20's unique characteristic of serving the major cities across New York without actually entering into them. Route 20 arrives in the Buffalo metropolitan area from the east, but before reaching the inner city it turns south, passing through the southern and southwestern suburbs, exiting the city to the west.

MAIN STREET, GENESEO, N. Y.

MAIN STREET, GENESEO, NEW YORK. In most towns, Route 20 treated visitors to views of residential neighborhoods when both entering and leaving the towns. This pleasant street is lined by stately trees and large houses. Improvements were underway when this photograph was made. Curbs have been installed on the left side of the street, and what appears to be the base for a streetlight is visible on the right.

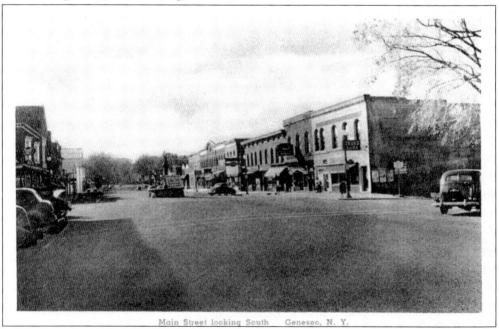

Main Street looking South Geneseo, N. Y.

MAIN STREET LOOKING SOUTH, GENESEO, NEW YORK. Several 1930s-era automobiles are diagonally parked on both sides of the Geneseo's Main Street. The town's famous Bear Statue, consisting of a circular base and upright pillar on top of which is a bronze bear, is prominently located in the middle of the street. The entire length of Main Street is listed on the National Register of Historic Places.

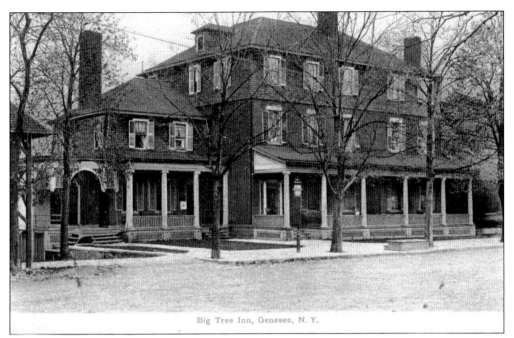

Big Tree Inn, Geneseo, N. Y.

BIG TREE INN, GENESEO, NEW YORK. Like its many counterparts on the expanding western frontier, the Big Tree Inn originally was a tavern and stagecoach stop. Opened in 1886, it has been a fixture in Geneseo for almost 125 years and ranks among the most significant buildings in the city's Main Street Historic District.

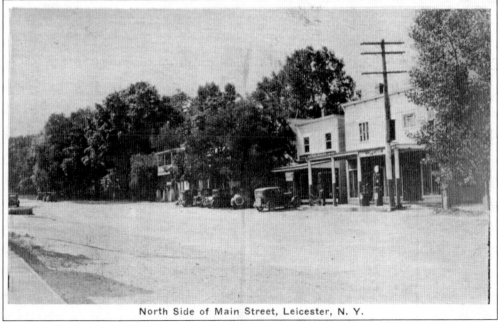

North Side of Main Street, Leicester, N. Y.

NORTH SIDE OF MAIN STREET, LEICESTER, NEW YORK. Even in the smallest of communities, Main Street could be counted on to provide a place for residents to obtain their basic supplies and to meet neighbors for a friendly chat. The gas pumps at the side of the street were an appreciated convenience for travelers passing through town.

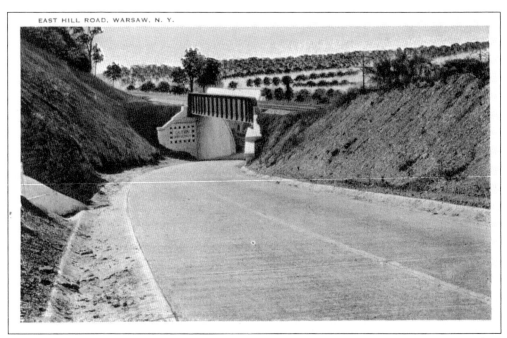

EAST HILL ROAD, WARSAW, N. Y.

EAST HILL, WARSAW, NEW YORK. Warsaw is located in a broad valley with steep hills both to the east and west. The underpass shown in this view was built to improve the grade level for trains as well as automobiles entering or leaving the city on Route 20. The construction appears to have been recently completed when this photograph was taken.

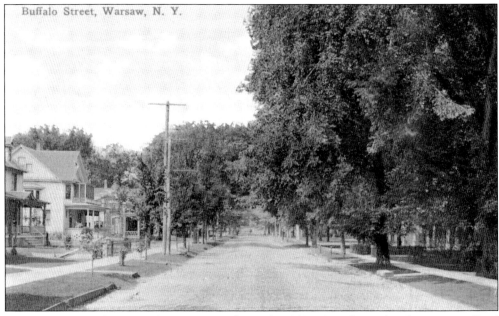

Buffalo Street, Warsaw, N. Y.

BUFFALO STREET, WARSAW, NEW YORK. This early-1920s view shows the pleasant tree-lined street before the surface was paved. Warsaw was the site where several abolitionists met in 1839 to form the Liberty Party, the first to have a platform advocating the abolition of slavery. The party did not gain prominence, but its efforts attracted other individuals and parties to take up the abolitionist cause.

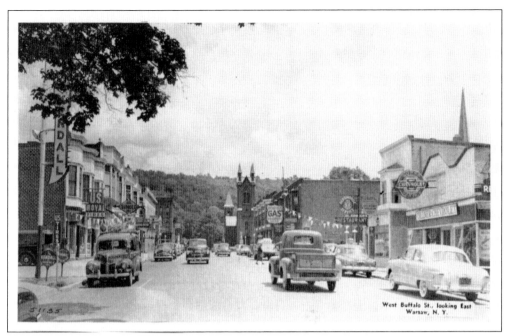

West Buffalo St., looking East
Warsaw, N. Y.

WEST BUFFALO STREET, WARSAW, NEW YORK. The business section in Warsaw is located primarily on Buffalo and Main Streets, which are perpendicular to each other in the center of the city. This card shows the view Route 20 travelers would have seen as they passed through the city on Buffalo Street.

SOLDIERS' AND SAILORS' MONUMENT, WARSAW, NEW YORK. This monument, located only a short distance from the intersection of Buffalo and Main Streets, is clearly visible to motorists on Route 20. The monument was erected in 1876–1877 to honor Civil War veterans. The entire area surrounding the monument, consisting of approximately 18 acres and 21 significant buildings, is on the National Register of Historic Places under the name Monument Circle Historic District.

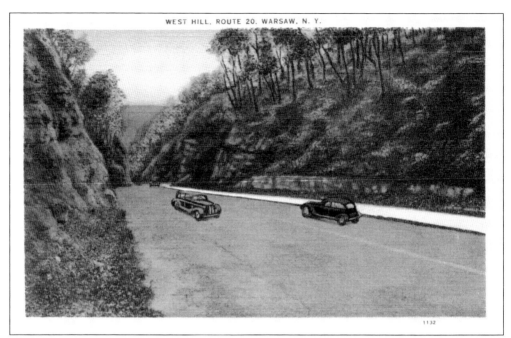

WEST HILL, WARSAW, NEW YORK. West of Warsaw, Route 20 went through rugged but attractive countryside. Considerable earth had been removed to improve the grade level of the road, and the roadbed had a hard surface. Three 1930s-era automobiles were on the highway when this photograph was taken.

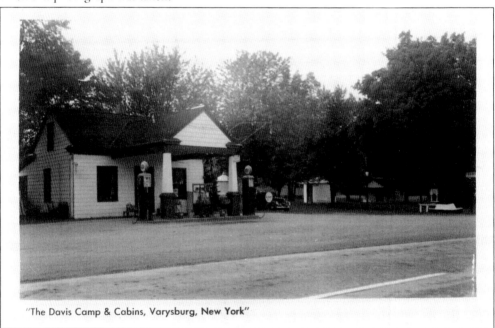

"The Davis Camp & Cabins, Varysburg, New York"

DAVIS CAMP AND CABINS, VARYSBURG, NEW YORK. The small community of Varysburg was located on Route 20 approximately 10 miles west of Warsaw. This photograph proves that when located on a major highway even the most rural community could support a tourist camp and service station.

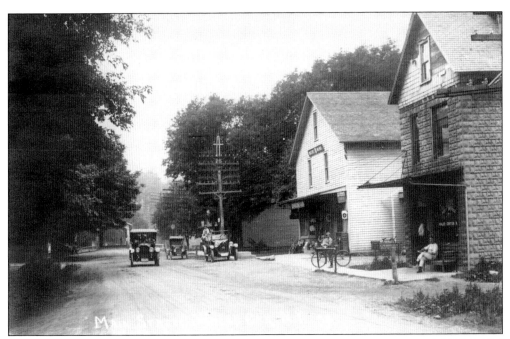

MAIN STREET, WALES CENTER, NEW YORK. Judging from the automobiles, this photograph predates Route 20's federal highway designation by a few years, but no doubt the view would have been much the same during the early years of the highway.

VIDLER'S 5 AND 10¢ STORE, EAST AURORA, NEW YORK. Variety or "dime" stores were a fixture on Main Streets throughout the country. Vidler's opened in 1930 and easily could have provided the inspiration for the 1931 hit song "I found a million dollar baby, in a five and ten cent store." The 1890 Vidler building featured a handmade gold leafed sign and a red and white striped awning.

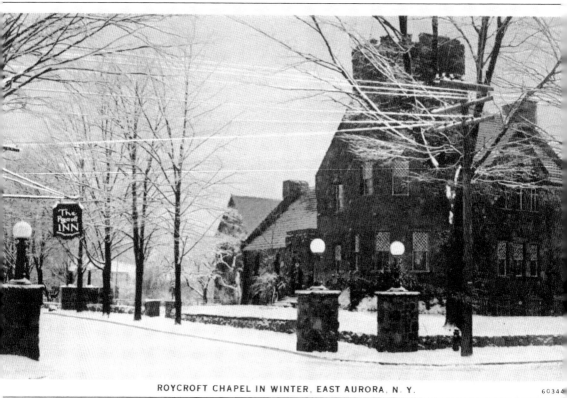

ROYCROFT CHAPEL IN WINTER, EAST AURORA, N. Y. 60344

ROYCROFT CHAPEL, EAST AURORA NEW YORK. The Roycroft Society was founded in 1895 by Elbert Hubbard to promote the arts and crafts movement in the United States. Hubbard was convinced that a self-contained community of dedicated artisans could succeed in New York. By 1910, upwards of 500 skilled craftsmen, including carpenters, furniture makers, leather smiths, and bookbinders had joined his movement. The Roycroft Society thrived for several years, and buildings were added, eventually reaching a total of 14. Tragically, Hubbard and his wife perished on May 17, 1915, when the luxury liner *Lusitania* was torpedoed by a German submarine. Over the following two decades, the Roycroft Society gradually declined, and it dissolved completely in 1938. The Roycroft Chapel was the landmark structure on the Roycroft campus. It had a castle-like appearance, including a large, round, crenellated tower. The chapel served as the meetinghouse for the Roycrofters, and after the Roycroft Society dissolved, it became the East Aurora Town Hall. The entire Roycroft campus is on the National Register of Historic Places.

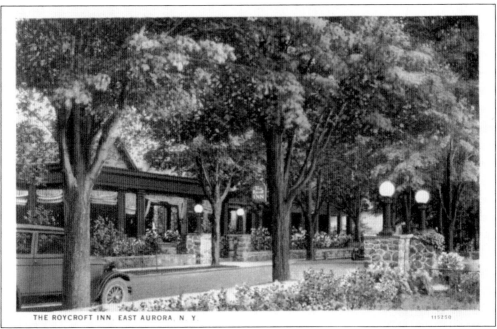

THE ROYCROFT INN, EAST AURORA, N.Y. 115250

ROYCROFT INN, EAST AURORA, NEW YORK. The Roycroft Inn opened in 1905 to accommodate the large number of people who were attracted to the Roycroft movement, either to join the utopian community, or as visitors. It continued under the aegis of the Roycroft Society until the entire community dissolved in 1938. The above photograph shows the exterior of the attractive craftsman-style building located on South Grove Street adjacent to the Roycroft Chapel. One of the inn's dining rooms, also adorned with craftsman-style woodwork and furniture, is shown in the photograph below. The Roycroft Inn is now owned by a nonprofit organization and has been converted to a first-class hotel.

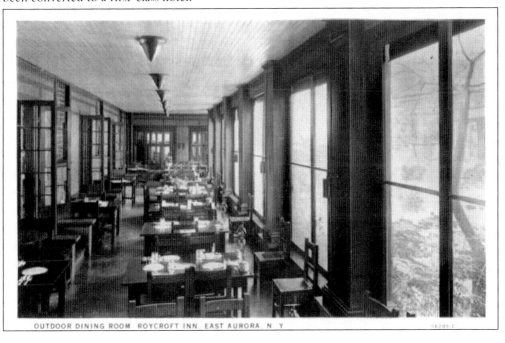

OUTDOOR DINING ROOM, ROYCROFT INN, EAST AURORA, N.Y. 56203-C

FILLMORE RESIDENCE, EAST AURORA, NEW YORK. Millard and Abigail Fillmore occupied this house from 1826 to 1830. It was hand built by the future president and is the only still existing house in which the Fillmores resided other than the White House. Originally located on Main Street across from Fillmore's law office, the house was moved in 1930 to its present location just two houses from Route 20.

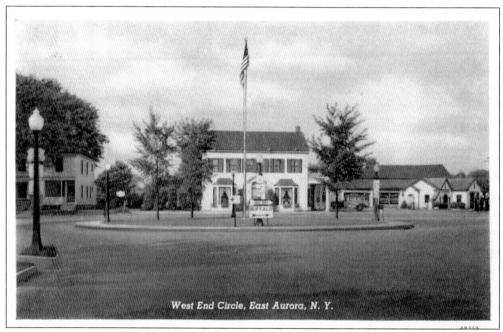

WEST END CIRCLE, EAST AURORA, NEW YORK. This attractive circle was located at the west end of East Aurora's Main Street. A Route 16 sign pointing to Buffalo is in the center of the picture. Further to the right another sign directed Route 20A traffic south of Buffalo. Both the 20A sign and the "Woodie" station wagon parked by the house indicate that this card is from the 1940s.

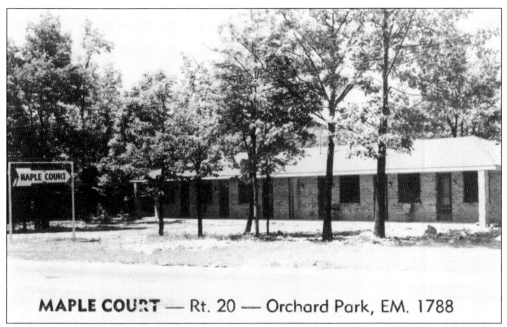

MAPLE COURT — Rt. 20 — Orchard Park, EM. 1788

MAPLE COURT, ORCHARD PARK, NEW YORK. This quiet roadside motel, located on Route 20 just east of Buffalo, was home for one night to "Daddy, Mommy and Grandma." They told their daughter at camp in New Jersey that they were having a wonderful trip. They had been through Michigan and Canada to Niagara Falls and were stopping in Buffalo before heading for home.

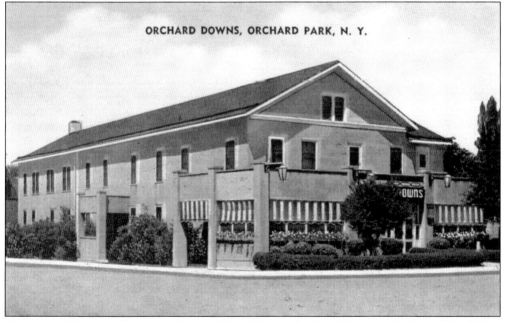

ORCHARD DOWNS, ORCHARD PARK, N. Y.

ORCHARD DOWNS, ORCHARD PARK, NEW YORK. Orchard Downs, the Inn of Tradition, was a landmark restaurant located at the intersection of Route 20A (original Route 20) and NY240. The inn's outstanding reputation was affirmed when owners of a new restaurant at the site promised "to return the tradition of dining and imbibing back to the historic four corners, a tradition interrupted with the demolition of Orchard Downs."

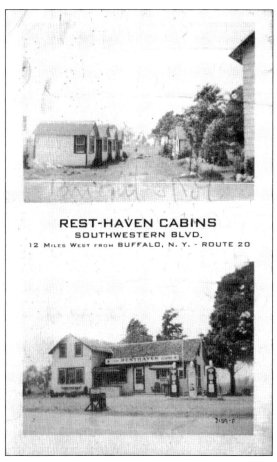

REST-HAVEN CABINS, BUFFALO, NEW YORK. Route 20 followed Southwestern Boulevard through the suburbs as it continued west from Buffalo toward Erie, Pennsylvania, passing this gas station, restaurant, and tourist camp along the way.

ROSE TEA GARDEN, EDEN, NEW YORK. Eden lies several miles south of Route 20 but most likely was the location of the post office that served this tourist camp. The large facility, located 18 miles west of Buffalo, contained two rows of single and double cabins and a restaurant. The owners described it as "a place to get a good night's rest after a long day's drive."

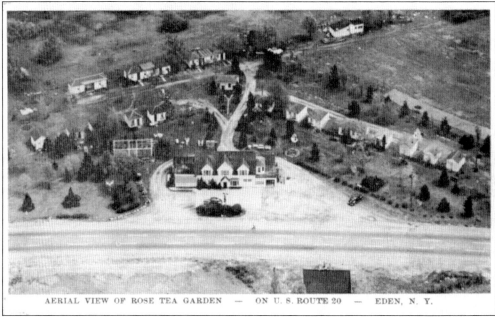

AERIAL VIEW OF ROSE TEA GARDEN — ON U. S. ROUTE 20 — EDEN, N. Y.

Seven

ALONG LAKE ERIE

The Lake Erie section of Route 20 lies entirely within Chautauqua County, paralleling the south shore of Lake Erie from Buffalo to the Pennsylvania border. This section did not have the panache of the other regions, such as Cherry Valley or Finger Lakes, partly due to its more remote location in extreme western New York and partly because of the county's unique triangular geography, which determined the character of traffic along the route. The broad eastern border of Chautauqua County opens to the entire state, whereas the western border between New York and Pennsylvania is only 20 miles in length. As New York's primary highway at the time, almost all automobile and truck traffic was funneled onto Route 20. It was a blue-collar road, serving commercial interests as well as leisure travelers.

Those who explored Chautauqua County were rewarded with sites equal to the other regions. The historic towns of Fredonia, Brocton, and Westfield had quaint main streets, significant architecture, and National Historic Sites that tourists could enjoy. Lake Erie was a great attractor, and most visitors destined for the lake arrived via Route 20. Other lakes contributed to the attractiveness of the county. Primary among them was Lake Chautauqua, a large lake located only a few miles south of Route 20. Lake Erie in the north, Lake Chautauqua in the center, and dozens of smaller lakes throughout the county gave credence to the boast that no spot in Chautauqua County was more than 25 miles from a freshwater lake.

Lake Chautauqua is home to the famous Chautauqua Institution. Founded in 1874 as a teaching camp for Sunday school teachers, during the early 20th century, it had evolved into a full-service continuing education facility offering courses based on the arts, education, religion, and recreation. The institution was especially known for its residential music program. By the 1930s, the simple campground had become a popular summer resort, bringing thousands of visitors to the area annually, many via Route 20. In 1973, the entire Chautauqua Institution Historic District was placed on the National Register of Historic Places.

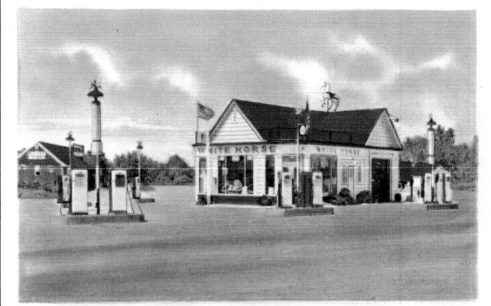

White Horse Service Station, on Routes U.S. 20 and N.Y. 5, Irving, N. Y. K5957

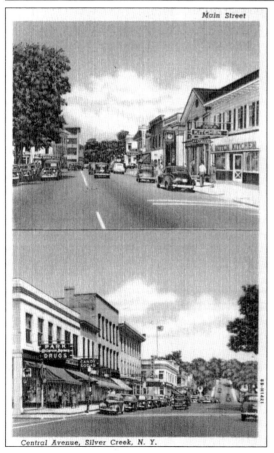

Main Street

Central Avenue, Silver Creek, N. Y.

WHITE HORSE SERVICE STATION, IRVING, NEW YORK. This Route 20 service station was well prepared to handle the heavy traffic between Buffalo and Erie, Pennsylvania, as it boasted at least eight gasoline pumps. Lubrication and minor repair services also were available. The station would have been hard to miss with its namesake white horse mounted on the roof.

MAIN STREET AND CENTRAL AVENUE, NEW YORK. Main Street and Central Avenue met at a T-intersection in the heart of Silver Creek's attractive business section. The two restaurants shown on the following page, Roof's and the Dutch Kitchen, can be identified on the right side of Main Street in the upper view at left.

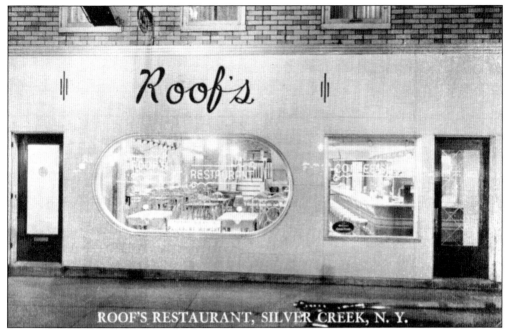

ROOF'S RESTAURANT, SILVER CREEK, N. Y.

ROOF'S RESTAURANT, SILVER CREEK, NEW YORK. Roof's Restaurant was up-to-date in the 1940s. The front facade with its oval window and the name of the restaurant written in script were decidedly art deco. The restaurant's motto was "Every Meal a Memory." Roof's was reputed to have the best doughnuts in town.

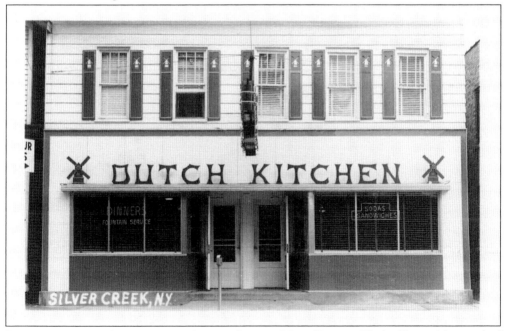

DUTCH KITCHEN RESTAURANT, SILVER CREEK, NEW YORK. Windmills at either end of the Dutch Kitchen sign gave authenticity to the old-world theme of this restaurant near the intersection of Main Street and Central Avenue in Silver Creek. The second floor also displayed smaller versions of the windmill on the shutters.

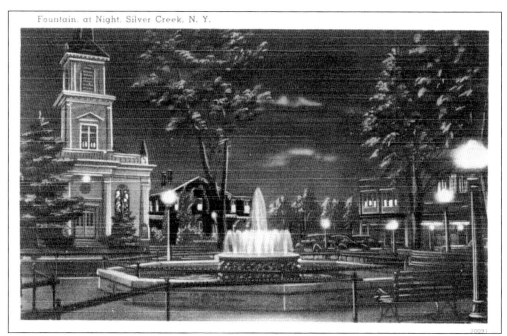

Fountain. at Night. Silver Creek. N. Y.

FOUNTAIN AT NIGHT, SILVER CREEK, NEW YORK. The village green in many small towns along Route 20 provided a pleasant location for local citizens to gather in the evening to visit with friends, or maybe listen to a band concert. The park in Silver Creek, located at the intersection of Main Street and Central Avenue, was particularly attractive with multicolored lights playing on the fountain as the highlight.

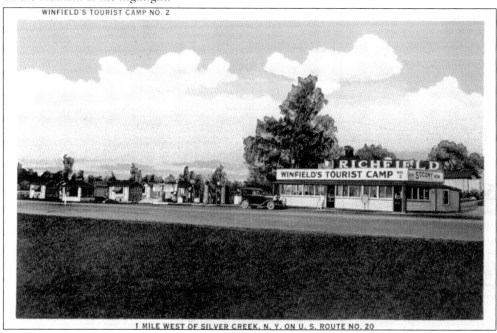

WINFIELD'S TOURIST CAMP NO. 2

1 MILE WEST OF SILVER CREEK, N. Y. ON U. S. ROUTE NO. 20

WINFIELD'S TOURIST CAMP, SILVER CREEK, NEW YORK. Travelers could spend the night in one of the small cabins or simply gas up at the filling station as they drove along Route 20. The business also included a restaurant.

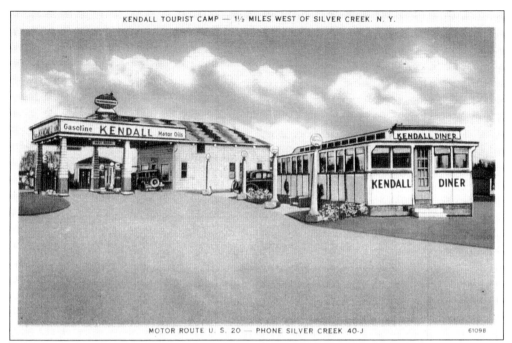

KENDALL TOURIST CAMP — 1½ MILES WEST OF SILVER CREEK. N. Y.

MOTOR ROUTE U. S. 20 — PHONE SILVER CREEK 40-J 61098

KENDALL TOURIST CAMP, SILVER CREEK, NEW YORK. Kendall's proclaimed itself to be "one of the finest tourist camps in the country, located in the heart of one of America's garden spots." The centerpiece of the establishment was the classic Kendall Diner. The complex included a service station housing restrooms and shower bath along with 49 furnished cottages.

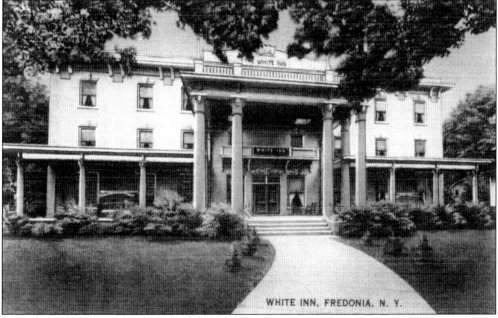

WHITE INN, FREDONIA, N. Y.

THE WHITE INN, FREDONIA, NEW YORK. This inn, built in 1811, is named for the original owner, Dr. Squire White, the first medical doctor in Chautauqua County. After a fire in 1868, the house was rebuilt by White's son. The property opened as an inn in 1919; it was included in the first edition of Duncan Hines's 1935 *Adventures in Good Eating.*

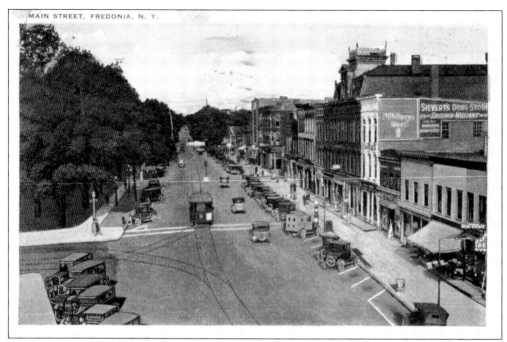

MAIN STREET, FREDONIA, NEW YORK. Automobiles and trolleys shared Fredonia's well-maintained Main Street in the 1920s. The lines designating diagonal parking at the curb and crosswalk appear to have been very recently painted. The village square, Barker Common, is the wooded area at left in the picture.

BARKER COMMON, FREDONIA, NEW YORK. Land for Barker Common was donated in 1825 by Hezekiah Barker for use as a public park. It was beautifully landscaped with trees, shrubs, and flowers. The park's two fountains, many benches, and a gazebo made it a pleasant place to relax and, during the summer, to enjoy music concerts. A drinking fountain was donated in 1913 by the Fredonia Women's Christian Temperance Union.

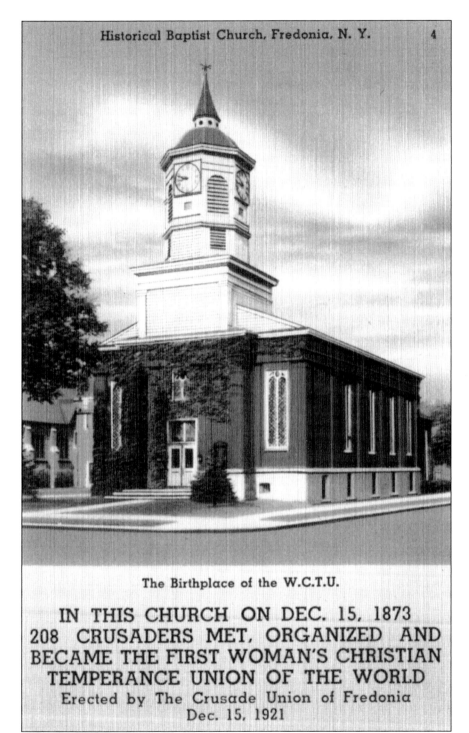

The Birthplace of the W.C.T.U.

IN THIS CHURCH ON DEC. 15, 1873
208 CRUSADERS MET, ORGANIZED AND
BECAME THE FIRST WOMAN'S CHRISTIAN
TEMPERANCE UNION OF THE WORLD
Erected by The Crusade Union of Fredonia
Dec. 15, 1921

BAPTIST CHURCH, FREDONIA, NEW YORK. As the legend on this card indicates, this historic church located adjacent to Barker Common in the center of Fredonia, was the birthplace of the Women's Christian Temperance Union. The church is part of the Fredonia Commons Historic District, which is listed on National Register of Historic Places.

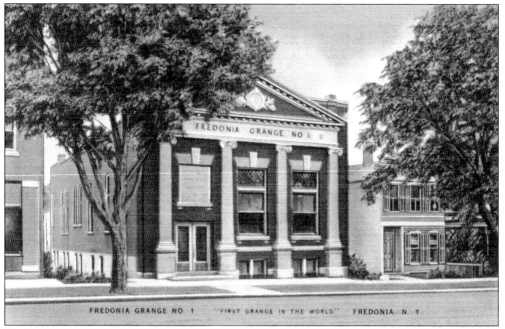

FREDONIA GRANGE NO. 1 "FIRST GRANGE IN THE WORLD" FREDONIA, N. Y.

GRANGE HALL NO. 1, FREDONIA, NEW YORK. The National Grange of the Order of Patrons of Husbandry is the oldest agricultural organization in the United States. Formed in 1868, it is the nation's strongest sustained organizational force working to assure a better life for rural Americans. This building is recognized as the first Grange hall in the country.

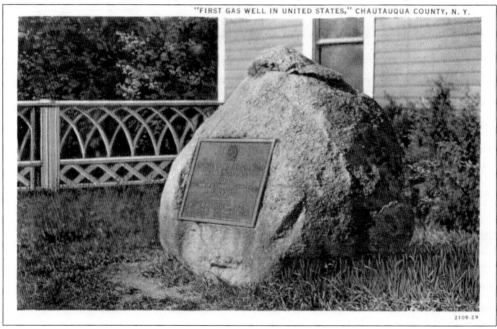

"FIRST GAS WELL IN UNITED STATES," CHAUTAUQUA COUNTY, N. Y.

FIRST GAS WELL IN THE UNITED STATES, FREDONIA, NEW YORK. In 1821, William Hart dug the first successful natural gas well in the United States. By 1825, it supplied power for lights in four stores and a gristmill. The plaque reads: "First gas well in the United States, lighted to honor the historic visit by General Lafayette, of American Revolutionary War fame, on June 4, 1825."

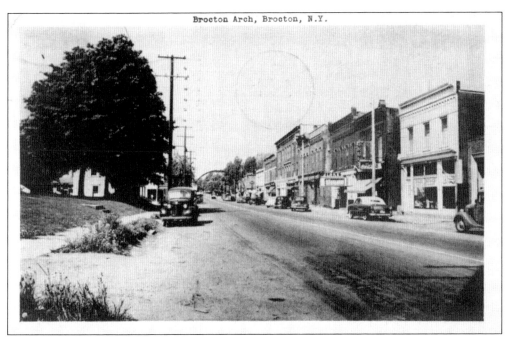

BROCTON ARCH, BROCTON, NEW YORK. In New York, a village is an administrative division of a larger entity, the town. In this instance, the village of Brocton is a part of the town of Portland, and the famous Brocton Arch was constructed in 1913 to commemorate the larger town's centennial. The arch can be seen in the distance in the above photograph and clearly in the close-up view in the photograph below. Two steel components extend diagonally from the four corners formed by the intersecting streets. The arches are joined together where they cross in the center of the intersection. The Brocton Arch is believed to be the only double arch east of the Mississippi River. It was added to the National Register of Historic Places in 1996.

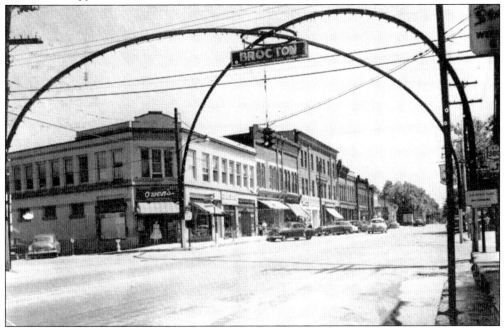

117

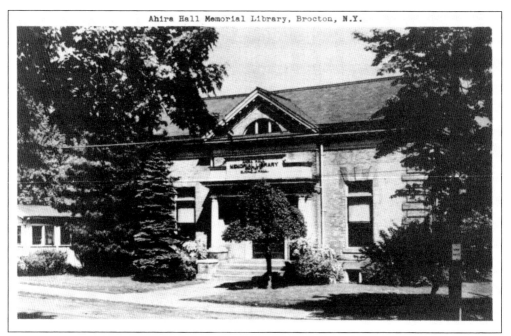

AHIRA HALL MEMORIAL LIBRARY, BROCTON, NEW YORK. In 1905, Ralph Hall endowed this library in honor of his father. He included the stipulation that if the building ceased to be used as a library, it was to be returned to his heirs. The library has served the community for more than a century with no need for Hall's stipulation to be enforced.

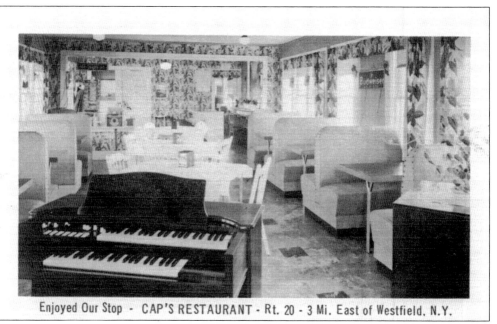

Enjoyed Our Stop - CAP'S RESTAURANT - Rt. 20 - 3 Mi. East of Westfield, N.Y.

CAP'S RESTAURANT, WESTFIELD, NEW YORK. Guests at Cap's were treated to organ music while they dined at this shiny art deco restaurant in the 1940s.

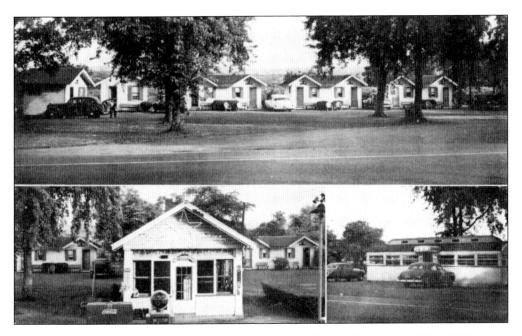

STARLITE TOURIST CAMP AND DINER, WESTFIELD, NEW YORK. The owners of this 1940s tourist camp engaged in some clever advertising in presenting their facility to the traveling public. The caption on the back of the card above describes the camp as "Your home away from home—A delightful place to stay while vacationing or just traveling" and lists Route 20 in Westfield as the location. The card below also lists the location as being on Route 20 in Westfield, but conveys the impression of a lakeside site. In fact, both Westfield and Route 20 were located approximately 8 miles south of the Lake Erie shoreline.

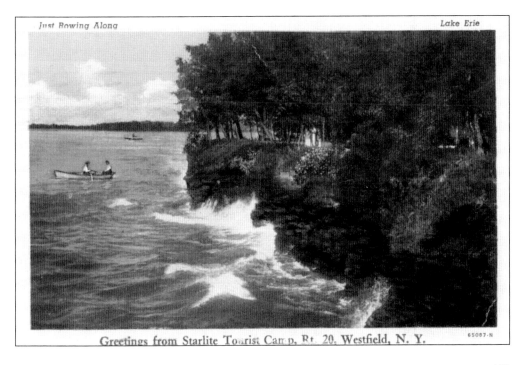

Just Rowing Along Lake Erie

Greetings from Starlite Tourist Camp, Rt. 20, Westfield, N. Y. 65087-N

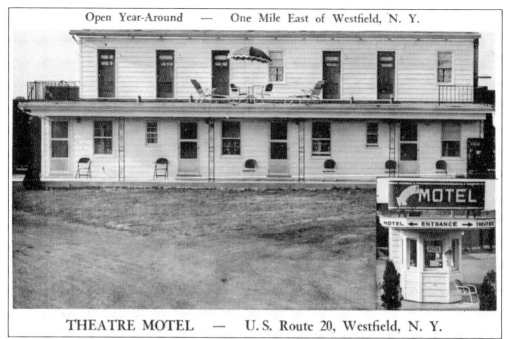

THEATRE MOTEL, WESTFIELD, NEW YORK. Guests could enjoy the fresh air while lounging on the roof of the Theatre Motel's porch. They had to be careful as there was no guardrail! First-floor occupants were furnished with folding chairs in front of their units. In keeping with its name, the motel advertised free movies, but the card did not identify the location where they were shown.

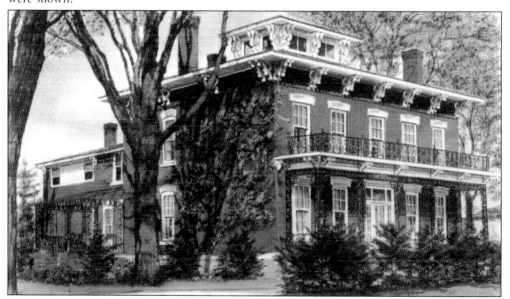

WESTFIELD MEMORIAL HOSPITAL, WESTFIELD, NEW YORK. During World War II, many Westfield physicians had been called to military service. Community leaders felt they could improve the effectiveness of the remaining physicians by providing them with a hospital. Local Rotarians spearheaded a fund drive and this building, described as a "Well-equipped hospital serving the region" opened in September 1942.

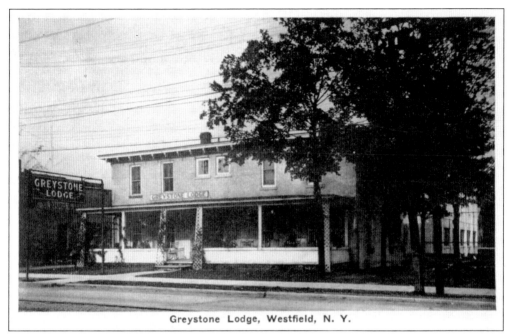

Greystone Lodge, Westfield, N. Y.

GREYSTONE LODGE, WESTFIELD, NEW YORK. Exterior (photograph above) and interior (photograph below) views show the Greystone Lodge to have been a pleasant roadside accommodation for motorists on Route 20. Located in Westfield, "The Gateway to the Lake Chautauqua Resort Region," it offered 40 clean, comfortable rooms and garage accommodations next door. Guests could relax either in the comfortable lounge or on the large front porch after enjoying a home-cooked meal in the lodge's restaurant. Recognition of the growing popularity of long distance automobile travel was evident from the caption on the back of the card. It states that the Greystone Lodge is "Midway between New York and Chicago on Route 20."

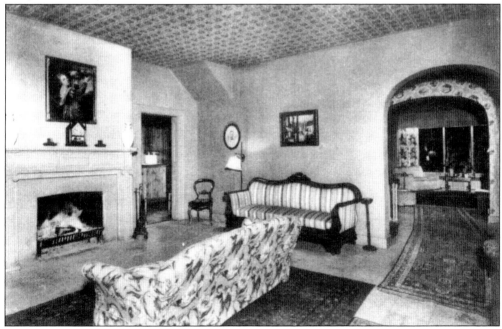

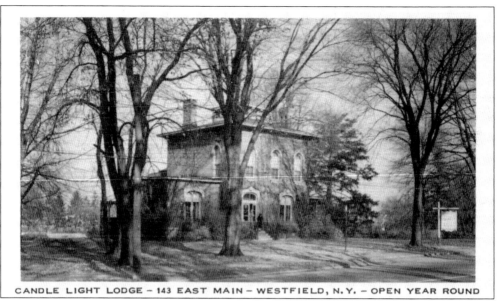

CANDLE LIGHT LODGE – 143 EAST MAIN – WESTFIELD, N.Y. – OPEN YEAR ROUND

CANDLE LIGHT LODGE, WESTFIELD, NEW YORK. East Main Street in Westfield is lined with stately homes, some dating to the 1800s. Over the years, some were converted into tourist accommodations for persons visiting the city, or passing through on Route 20. The Candle Light Lodge offered rooms with and without baths by the day or week and was within easy walking distance of downtown Westfield.

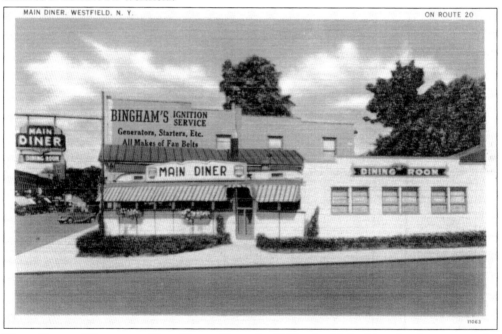

MAIN DINER, WESTFIELD, NEW YORK. Since the 1920s, the Main Diner has been a popular gathering place for Westfield's citizens. Through many ownership changes, it has maintained its old-time atmosphere. Whether intended or not, Bingham's Ignition Service received equal billing with the Main Diner on this 1930s card. The diner was "Always Open" and would have been a good place to pass the time while one's car was being repaired.

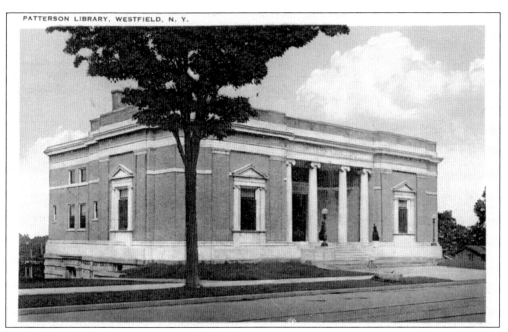

PATTERSON LIBRARY, WESTFIELD, NEW YORK. Patterson Library was created by a $100,000 bequest in the will of Hannah Whiting Patterson in memory of her parents. Following several years of operation in temporary quarters, the library shown on this postcard opened on August 1, 1908, amid a grand celebration. The Patterson Library is known locally as Westfield's "magnificent legacy."

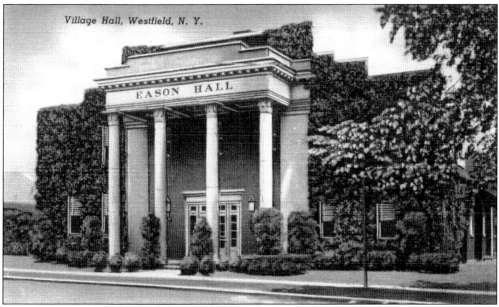

Village Hall, Westfield, N. Y.

EASON HALL

EASON HALL, WESTFIELD, NEW YORK. Eason Hall was endowed by Clara Eason to honor her parents. Located just off Main Street, it has been the site of many community events. An earlier Westfield resident, 11-year-old Grace Bedell, is remembered for encouraging Abraham Lincoln to grow a beard to improve his chances of winning the presidency. When Lincoln visited the town, he invited Grace to the podium to show her his beard.

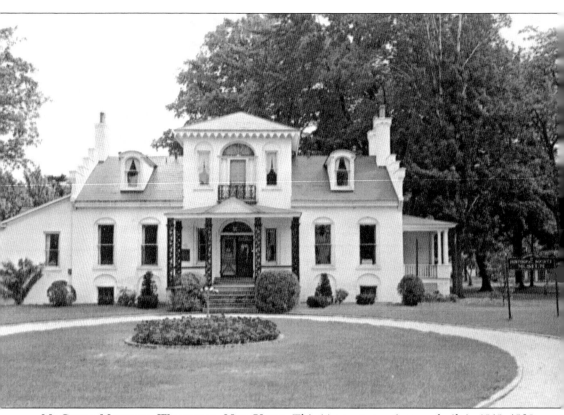

McClurg Mansion, Westfield, New York. This 14-room mansion was built in 1818–1820 by James McClurg, son of a Pittsburgh industrialist and a wealthy merchant in his own right. In 1938, McClurg's grandson, Dr. William Moore, donated the residence and the entire grounds to the city. Interestingly, the word "Folly" has twice been applied to occupants of McClurg Mansion. Initially, it became known as "McClurg's Folly" due to its opulence in contrast to other homes on the frontier. From 1836 through 1838, the mansion was occupied by William Seward, who later became secretary of state in the Lincoln administration and negotiated the purchase of Alaska. Newspapers of the day referred to that transaction as "Seward's Folly." The mansion became a museum in 1950 under the aegis of the Chautauqua County Historical Society.

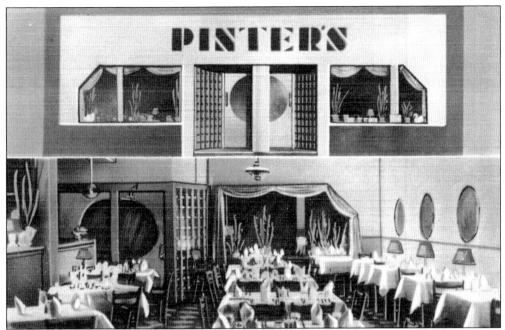

PINTER'S RESTAURANT AND COCKTAIL BAR, WESTFIELD, NEW YORK. The caption on this card exults Pinter's as the "Finest Eating Place Between Cleveland, Ohio, and Buffalo, New York." The art deco facade and colorful interior gave it an up-to-date feeling. The restaurant was approved by Duncan Hines and was a member of the National Restaurant Association. Travelers were advised to "just look for the traffic light on Route 20."

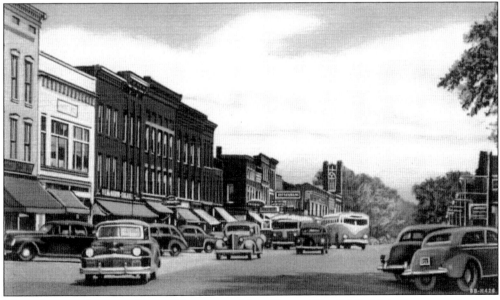

MAIN STREET LOOKING EAST, WESTFIELD, NEW YORK. Westfield's Main Street was busy on the day this photograph was taken. Although it cannot be determined from the card, the local bus station probably was in one of the buildings on the left side of the street. One bus is parked at the curb, and another appears to be just pulling into the street. The automobiles are from the 1930s and early 1940s.

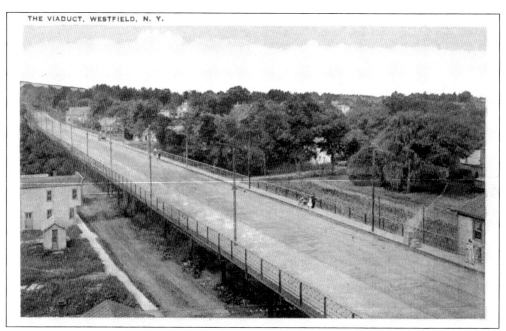

MAIN STREET VIADUCT, WESTFIELD, NEW YORK. This elevated roadway replaced Westfield's former bridge over Chautauqua Creek. The first trolley crossed the viaduct January 1, 1909, making possible travel without interruption from Buffalo to Erie, Pennsylvania. Prior to that time, passengers crossed the bridge on foot before continuing their journey on a second trolley. This viaduct remained in service until the late 1980s, when it was rebuilt, resulting in the present bridge.

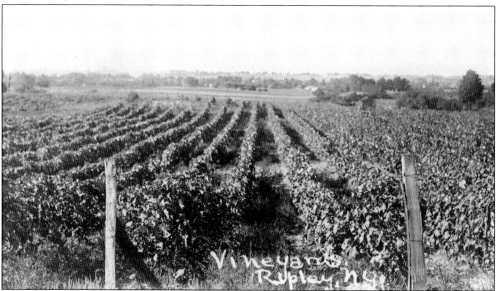

VINEYARD, RIPLEY, NEW YORK. The climate in western New York and eastern Pennsylvania is ideally suited for growing grapes. From the early 1900s, the region extending from Erie, Pennsylvania, to the Finger Lakes became increasingly prominent in grape production. Vineyards were a common sight along both sides of Route 20, adding to the beauty and interest of the roadway.

STATE ROAD, RIPLEY, NEW YORK. The paved roadbed and cement work on the bridge were fairly new when this picture was taken. As it is the only state road in the area, it is reasonable to conclude that this is a photograph of Route 20. The back of the card conveyed a tragic message. It says, "We are all well. Here is the road that goes up to where we were left homeless."

TOURIST HOME, RIPLEY, NEW YORK. No attempt was made to emphasize the attractiveness of this stately home. It was called simply Tourist Home. Its location in the westernmost community in New York through which Route 20 passed probably made this the last tourist accommodation for a westbound traveler before leaving New York.

DISCOVER THOUSANDS OF LOCAL HISTORY BOOKS
FEATURING MILLIONS OF VINTAGE IMAGES

Arcadia Publishing, the leading local history publisher in the United States, is committed to making history accessible and meaningful through publishing books that celebrate and preserve the heritage of America's people and places.

Find more books like this at
www.arcadiapublishing.com

Search for your hometown history, your old stomping grounds, and even your favorite sports team.